ALDERNEY

From Old Photographs

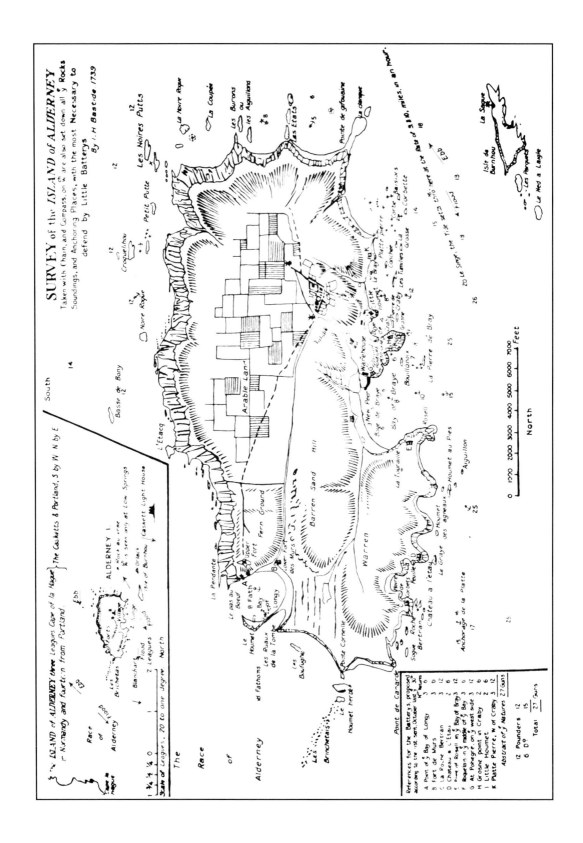

ALDERNEY
From Old Photographs

BRIAN BONNARD

AMBERLEY

To the people of Alderney, as a tribute to their past, and to provide memories of that past for the present and future generations.

First published by Alan Sutton Publishing Limited, 1991
This edition published 2009

Copyright © Brian Bonnard 2009

Amberley Publishing
Cirencester Road, Chalford,
Stroud, Gloucestershire, GL6 8PE

British Library Cataloguing in Publication Data.
A catalogue record for this book is available from the British Library.

ISBN 978-1-84868-360-0

Typesetting and origination by Amberley Publishing
Printed in Great Britain

Contents

Introduction 6

1. The Island, its Harbours, and Ships 9

2. The Forts 33

3. St Annes, Church, Town and Industries 43

4. The People of Alderney 73

5. Alderney Agriculture 91

6. Air, Road and Rail Transport 105

7. Coastal Scenes 115

8. Lighthouses and Wrecks 121

9. The Alderney Militia and the Army 131

10. The German Occupation 139

11. The Islanders Return, Alderney 1945-60 147

Acknowledgements 160

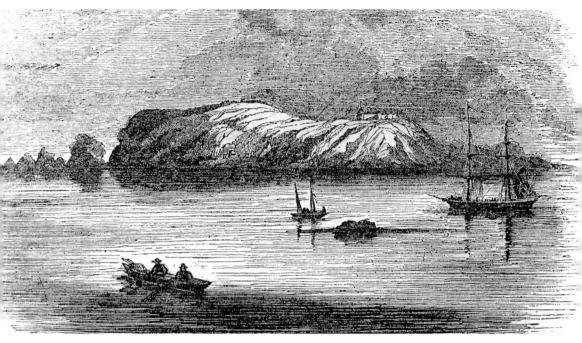

A WOODCUT BY W.A. DELAMOTE OF OXFORD, published in the monthly supplement to the *Penny Magazine of the Society for the Diffusion of Useful Knowledge*, dated 30 September 1837. The view, from the south-east, shows Essex Castle on the hilltop, and Longis Harbour on the right.

Introduction

The photographs in this volume span almost exactly a century. The earliest date from 1859, a small series of faded photographs of the principal forts, now in the possession of the States of Alderney. Taken by an unknown photographer, these appear to have been part of some official record of the period. A few older lithographs, and reproductions of maps and paintings, are also included.

Alderney, about 3½ miles long and 1½ miles wide at its widest, is the third largest of the Channel Islands, and has a population today of about 2,400. Its landscape is based on a rocky plateau rising to about 300 ft in the south and west, with vertical cliffs and many small, hidden, and almost inaccessible bays. This plateau slopes quite steeply down to the north where the principal harbour is situated in Braye Bay, which is dominated and protected by the massive Victorian Breakwater, and also down to the low, sandy, eastern end, from Essex Hill. Below this is the earliest harbour, used from Roman times until about 1736, situated on the south side of the island at Longis Bay, which itself is now dominated by the German sea-wall.

The island is surrounded by many dangerous reefs, and offshore sunken or emergent rocks, the scene of almost three hundred wrecks in the last four centuries in addition to many small

fishing craft which have vanished without trace. The swift 8-knot currents in the Swinge and the Race have trapped many unwary sailors, but provide some spectacular sights in rough-weather conditions.

Except for the high cliff area along the south coast, the island has a ring of Victorian forts, built to protect the Breakwater and prevent invasion by the French. These are very evident on several hilltops and offshore islands, and form an imposing part of the landscape. The remains of earlier sixteenth- and eighteenthcentury fortifications and batteries still exist in many places, and add to the scenic attractions of several areas.

Less attractive are the remains of the German fortifications, built by slave-labour and much loss of life during the Second World War. Most obvious and visible from many parts of Alderney is the *Marinepeilstände* or Fire Control Tower, known locally as The Odeon because of its resemblance to some of the 1930s chain of cinemas of that name. Less obvious today is the huge concentration of bunkers, gun emplacements, and underground shelters and stores connected with the various defensive batteries, many of which are now partially concealed by vegetation. Least obvious of all are the several networks of storage tunnels honeycombing the hillsides in many places, several now blocked off entirely, and the remainder in a somewhat dangerous condition.

Unlike the two larger Channel Islands of Jersey and Guernsey, where no more than about half the population was evacuated during the last war, Alderney was evacuated by all but a handful of its inhabitants on 23 June 1940, about two weeks before the advancing German forces occupied the island, and subsequently turned it into a vast slave-labour camp and fortress.

The evacuation took place on a Sunday morning at only a few hours' notice. Six small ships were sent by the British government, and the population were only allowed to take what they could carry in a suitcase. This inevitably meant that many albums of family photographs, and virtually all the official records, except for the Parish Registers, were left behind. When the people began to return at Christmas 1945, they found that most of what had been left behind had vanished, having been looted or destroyed in the intervening five and a half years.

Because of this, there is a lack of photographic material from the period before 1945, compared with Guernsey and Jersey. Since it was founded in 1966, The Alderney Society Museum has been given more than two hundred old postcards, and pictures of island events from before and during the war, and some of these are included. The Alderney Library has an album of photographs taken by Sonderführer Hans Herzog, the Civilian Administrator of FK 515 appointed by the occupying power in 1941, which he sent to an Alderney resident in the 1960s, and a selection from those which have not been published previously has been used. My thanks are due to the Society and the Library for permission to use these.

For some six years, the author has been collecting old postcards, and copying other postcards and photographs loaned by island residents and visitors, including several members of the German war-time forces in Alderney, in an attempt to build up as comprehensive a photographic record of the island's past as possible. This collection now comprises about one and a half thousand pictures, and in due course will be deposited in the museum. In many cases the hardest part has been identifying the people shown in the photographs, few of which had any information written on them. For any mistakes in this respect the author offers his apologies, and would be most appreciative of any corrections to the captions which readers can supply.

Only a handful of these photographs have been printed previously in any book about the

Channel Islands published in the last fifty years, but some of the oldest illustrations come from works published during the nineteenth and early twentieth centuries. Wherever possible the sources have been acknowledged, and the author is most grateful to all those who have loaned their precious photographs, a list of whom will be found at the end of the volume.

The remainder of the photographs come from the author's own collection, or from the old records of various military and other official bodies connected with the island since Victorian times. All of the pictures were taken prior to 1955, except for seven of the author's own more recent photographs, included to build up a more complete whole.

Since 1870 many photographs of Alderney have been taken and published as postcards by Guernsey photographers, and there have also been a number of Alderney-based photographers to record the local scene.

Foremost among these was Thomas Westness, operating from Guernsey from 1884 to about the turn of the century, when he moved to Alderney, where he stayed until 1919. Many of his views were printed over and over by various postcard publishers until the 1930s, and his sister Julia, born in 1866, still continued with the photographic studio in Les Rocquettes, Alderney, until the evacuation in 1940.

T.A. Grut started working in Victoria Crescent, Guernsey, in 1879, continuing there until 1894. T. Singleton was working in the 1870-90s, and A. Heatley around the turn of the century, with F.W. Guerin about 1910-20.

Thomas Bramley, in the 1920s and '30s, produced many fine, sharply focussed harbour and coastal scenes, and Norman Grut, who published some postcards, but did rather more studio work, was working at about the same time. Local views produced by his studio continued to be published into the 1950s.

C.R. Le Cocq in Alderney, in the period from 1900 to the end of the First World War, made a comprehensive survey of the work done on the Breakwater, and recorded many island scenes and wrecks at the same time. He died before the evacuation.

Miss Mary Connolly, who was born in 1910, kept a studio in Victoria Street in Alderney in the 1930s, and much of her work was published as brightly coloured cards. After the Second World War, she married cartoonist and publisher of *The Alderney Times*, Ian Glasgow. Also in the 1930s, W. & E. Bailey, a father and daughter team, had their studio in Valongis. They left Alderney before the Second World War. W. (Wally) Royston Gaudion, in the early 1900s, and W.T. Oliver, in the 1930s, also had some of their work printed as postcards.

After the Second World War, many of the pre-war cards were re-issued for the tourists, and some pictures of the damage and destruction left by the Germans, taken by Alasdair Alpin McGregor, were also published as postcards.

Over the years, many of the postcards were published by Valentine's, Judge's, Raphael Tuck, and BB of London, as well as by various Channel Island printers. The quality and sharpness of the originals varies greatly, and in some cases the same original print has been published at different times by a number of companies, making identification of the photographer less certain. As far as possible the earliest copy has been traced and used in this volume.

Brian Bonnard, Le Petit Val, Alderney

SECTION ONE

The Island, Its Harbours, and Ships

The Island's earliest harbour from Roman times, and the principal one to 1736, was at Longis Bay, where a stone jetty, the ruins of which may still be seen on the western side, was built in 1661, probably on the site of an earlier one.

A secondary anchorage, or a harbour for small craft, was at Crabby, later incorporated as the New Harbour, or 'Little Crabby Harbour' within the Breakwater development. The principal port was moved to Braye with the building of the 'New Pier' now known as the 'Old Harbour' in 1736, and batteries were built to defend it and Braye Bay from all sides. Victorian developments from 1847 onwards now dominate the Braye harbour area.

Of all the shipping to use the port, the two ships both named SS Courier were probably the most important, being the island's regular supply boats from 1876 to 1947, except for the period of the Second World War. The 99 ft long, 'little' Courier was built especially for the service in February 1876, followed in 1883, by the similar-looking, 150 ft, 'big' Courier. She first tied up at the 'New Jetty' on 17 May 1897, shortly after completion.

'Big' Courier had an eventful career. She towed in several disabled vessels to Alderney, was involved in a number of rescues, including that of twelve men and a woman from the wreck of Ville de Malaga off the Casquets in August 1897, when seven drowned, and was beached after striking the eastern arm of Little Crabby Harbour in 1905, and again later that year when she struck a rock off Crevichon. Her eighty-six passengers landed on Herm and Jethou without any loss of life. In 1906 she struck another rock off Jethou and sank with the loss of several lives. It took three months to refloat her. She was repaired by her builders and returned to the regular run for a further thirty-three years. She saw service in England throughout the Second World War, and afterwards returned to the Alderney run for about a year. At this time she was probably the oldest steamer still in service. She remained derelict in England from then, until she was scrapped in Holland in 1951.

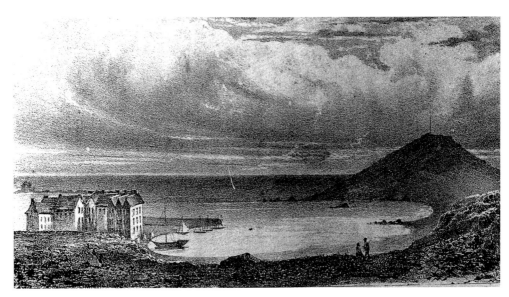

A VIEW OF BRAYE HARBOUR FROM THE SOUTH, drawn by R. Kent, and published in John Jacob's *Annals of the British Norman Isles* in 1830. The signal mast on Mount Touraille erected about 1810 is shown on the right. The battery there was built in 1806 at a cost of £4,003 18*s.* 6*d.*, on the site of a former watchtower erected about 1550 by Robert Tuberville, Marshall of Alderney.

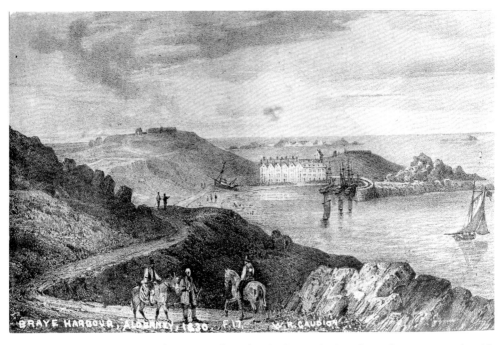

BRAYE HARBOUR in 1830, from an etching by C. Carey. A view from the eastern end, with Burhou in the background, issued as a postcard by W.R. Gaudion about 1910.

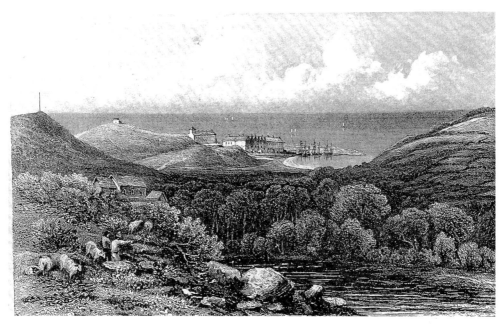

THE BRAY, drawn by G.S. Shepherd, and engraved and published by J. Shury & Sons in 1855. This picture, strangely, does not include the Breakwater which was well under way by then. The church-like building left of centre is the school and chapel, erected for the government workers and their children about 1850. The Lloyd's signal mast on the Butes (left) was in communication with the Casquets Lighthouse.

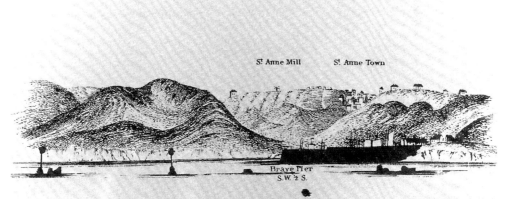

SAILING DIRECTIONS FOR THE HARBOUR about 1830.

A NORTH PROSPECT OF THE ISLAND OF ALDERNEY by John Henry Bastide, 1740.
Bastide was a member of the Board of Ordnance from 1733, and became its Director in 1748. He

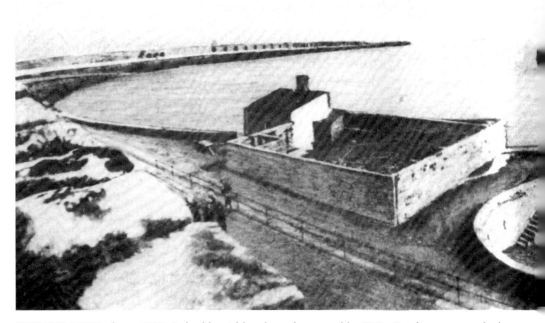

THE HARBOUR about 1900. A double width coloured postcard by W.R. Gaudion, postmarked
1904. The steam-launch *Maude* is marked with a cross, and the pilot launch *Volage* is tied up

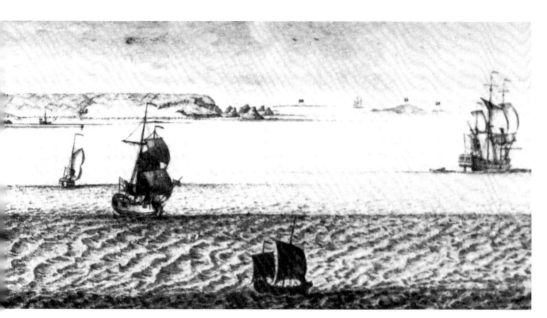

made accurate surveys of the Channel Islands, and drew several similar pictures of them.

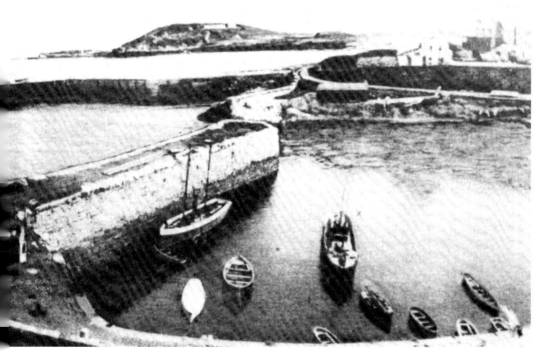

by the wall. The square compound was then the coal yard, and the building on its corner is the Blacksmith's shop.

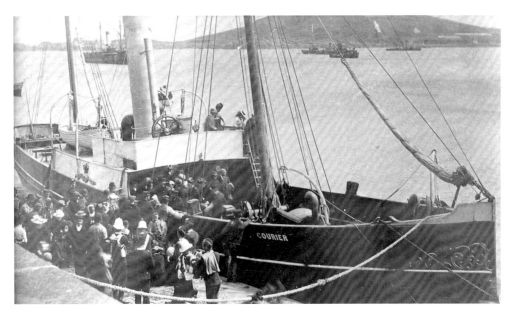

THE 'LITTLE' *COURIER*. The first of two similar-looking ships of the same name. Launched on 26 February 1876, the 136-ton vessel was built by Day & Summers of Southampton for Barbenson & Co. (in 1897 to become the Alderney Steam Packet Company). Both were also equipped with sails. She was sold to a Greek company in 1913, and renamed *Ahdon*. This photograph taken in 1896 shows passengers, including troops, embarking and disembarking at the Breakwater slipway. The card has the message on the back 'Tom with new helmet, love Mum Lihou.'

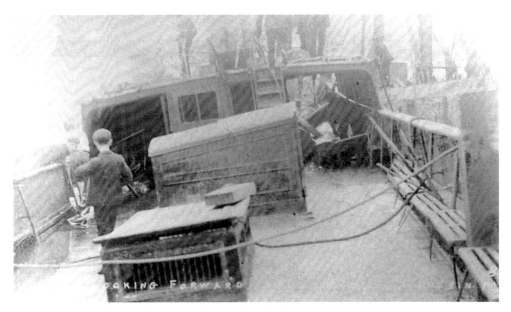

ON THE DECK OF *COURIER* about 1900. A postcard by F.W. de Guerin.

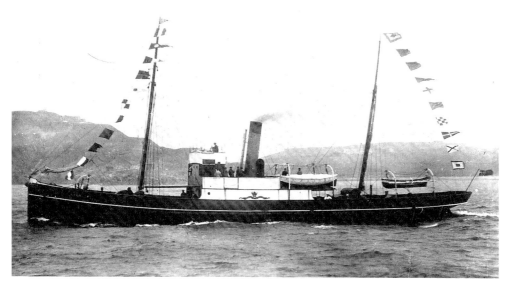

THE 'BIG' *COURIER* of 150 tons was built in 1883 by the same builders as her namesake, at a cost of between seven and eight thousand pounds. She ran a service between Guernsey and Alderney four times a week in summer and twice in winter until 1940. Capable of carrying up to 100 passengers and the cargo and mails, she was the last vessel to leave the island before the Occupation, with a cargo of pigs removed by a Guernsey working party after the islanders had left. She came under air attack as she reached St Peter Port, and was beached. She took the cargo on to Southampton next day. In 1935 the fare was 9s. (45p) return. This photograph was taken from the Breakwater about 1900, when both *Couriers* were running on the route. Note the additional lifeboat compared with 'little' *Courier*, and the black top to the funnel.

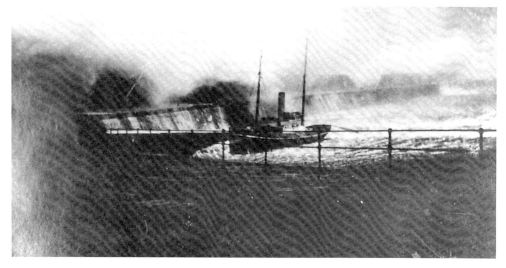

COURIER AT THE SLIPWAY in a north-west gale about 1900. Photograph by Westness. The card is postmarked 4 May 1906.

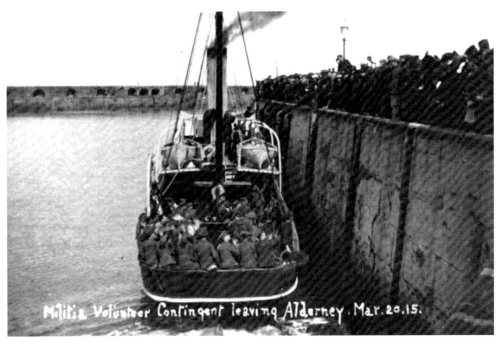

Militia Volunteer Contingent leaving Alderney. Mar.20.15.

COURIER TAKING THE VOLUNTEER CONTINGENT OF THE ALDERNEY MILITIA to the First World War, 20 March 1915. Military Service was not compulsory for Channel Islanders at this time.

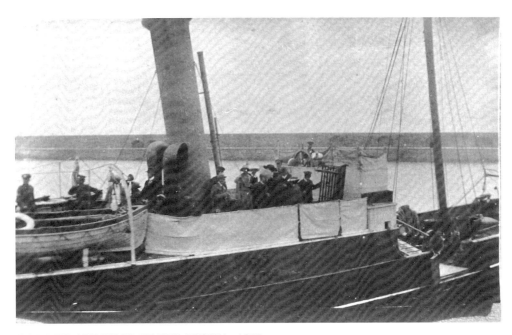

COURIER ARRIVING AT THE JETTY in 1922.

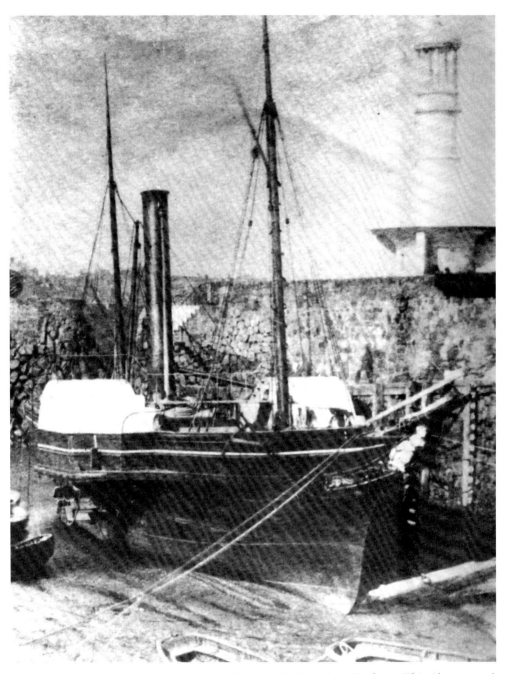

PADDLE STEAMER *QUEEN OF THE ISLES* in St Peter Port Harbour. This 8l-ton vessel, built in 1853, was bought by Breakwater contractors Jackson & Bean, and ran from November that year, until 1872, between Guernsey, Alderney and Cherbourg. The figurehead is of Queen Victoria. *Queen of the Isles* could carry 70 passengers, had 25 berths, and the return fare between Alderney and Guernsey in 1859 was 3*s.* 6*d.* in the main cabin, and 2*s.* 6*d.* in the fore cabin.

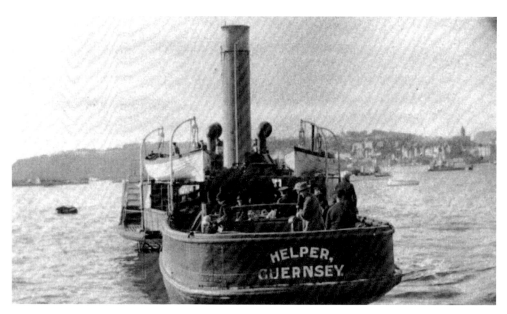

PADDLE STEAMER *HELPER* arriving at St Peter Port from Alderney in the 1920s. The legend on the back of the postcard reads, 'Uncle Jim Audoire with trilby'. The 173-ton *Helper*, originally named *Sir Francis Drake*, was built in 1875 as a tug, renamed in 1908, bought by the Alderney Steam Packet Co. in 1920, and used mainly between Guernsey and Sark.

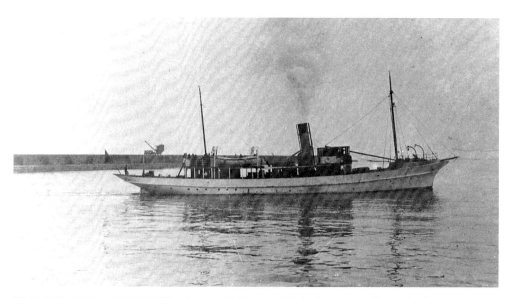

RMS *RIDUNA* AT BRAYE. The 350-ton *Riduna*, built in 1905, was formerly the Coastguard Cutter HMS *Argus*. She replaced *Helper* after she was badly damaged at Sark in 1926 and was scrapped. The return fare to Guernsey aboard this vessel was 7s. 6d. The postmark on this card reads 1927.

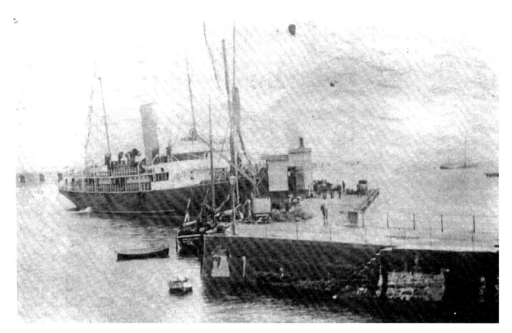

SS *ALBERTA* was delivered to the Great Western Railway for the Channel Islands run in 1900, shortly after *Stella* was sunk on the Casquets. The postmark on this card is 1904.

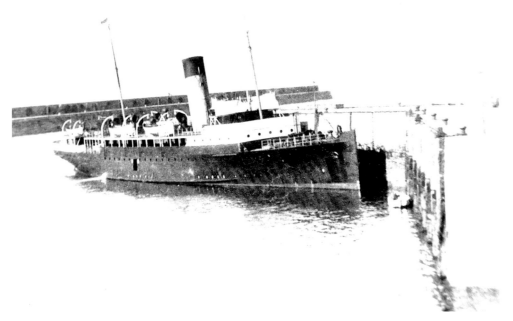

SS *VERA* an LSWR passenger steamer, was introduced to the route in 1898, and took part in the rescue of some of the passengers from Stella. She was taken over by the Southern Railway in 1923, and scrapped in 1933. This picture was taken on a box camera in 1932.

SS *STAFFA* AT BRAYE in 1940, shortly before the evacuation. *Staffa* was taken over by the Germans, and used between the islands until her crew apparently sabotaged her, and she sank just off the Alderney jetty near the entrance to the New Harbour in 1942. She remained there, half-sunk, throughout the war, and was finally salvaged in 1951. The mate, Jock le Feuvre, is on the prow, and skipper, Ernie Carré, at the wheelhouse.

A 'POTTER', probably the French vessel *Marie Magdalene*, off the Casquets in May 1940. This photograph was taken by John Everett, a young officer of the Machine Gun Training Centre, about two weeks before the evacuation.

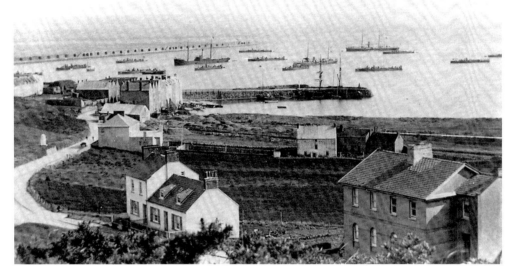

THE CHANNEL FLEET IN BRAYE HARBOUR, August 1901. On the extreme left is English Row which was later demolished. This photograph is probably by Westness.

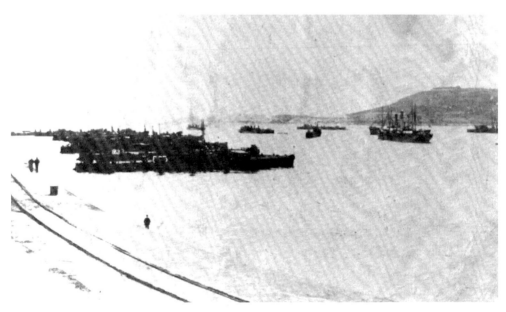

DESTROYERS OF THE CHANNEL FLEET, tied up stern to the Breakwater, during manoevres in 1904 or 1906.

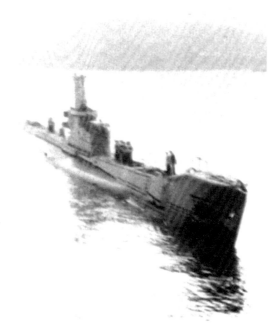

THE 'A' CLASS SUBMARINE HMS *Alderney* at Braye in 1947.

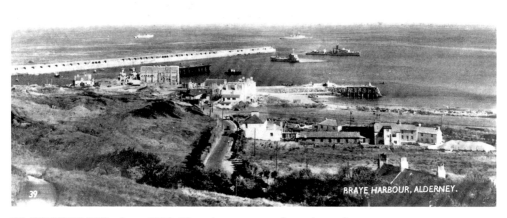

BRAYE HARBOUR about 1950. Note the presence of naval vessels.

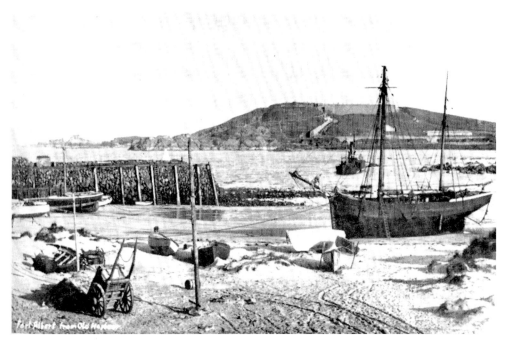

THE OLD HARBOUR AND FORT ALBERT, probably about 1900.

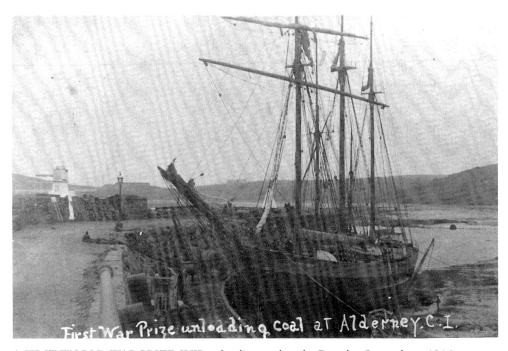

A FIRST WORLD WAR PRIZE SHIP unloading coal at the Douglas Quay about 1916.

MV *GUERNEYSEYMAN* UNLOADING GENERAL CARGO in the New Harbour about 1935. Her skipper was Vic Petit. Fishing vessel *New Sunrise*, owned by Pilot Jack Quinain Snr, is clearing lines beside it. *Sunrise* was blown up by a German mine later, during the war.

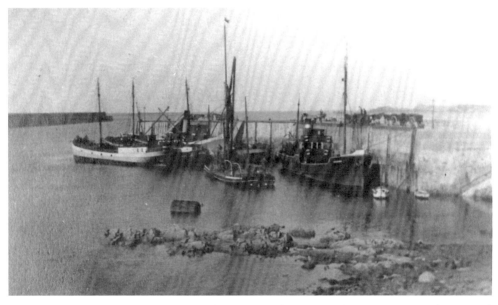

SS *YORK VALLEY*, a 750-ton ship, loading granite chippings at the jetty in 1936. Three Dutch MVs *Hebe*, *Albion*, and *Argus* are waiting, SS *Abbotsford* is discharging coal, and the barges are *Emma* and *May Margaret*.

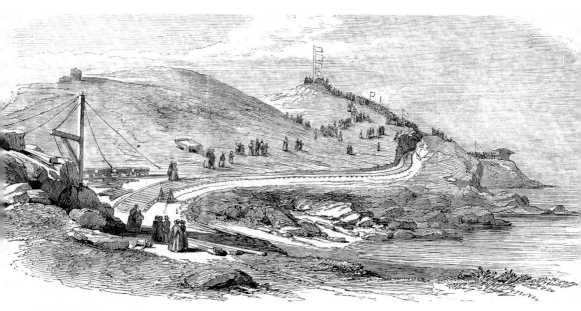

THE FOUNDING OF THE HARBOUR OF REFUGE. This occurred on 12 February 1847 and was fully reported in the Guernsey *Comet*. This sketch by Paul Naftel, made on the day, was published with an abridged report in the *Illustrated London News* on 20 February.

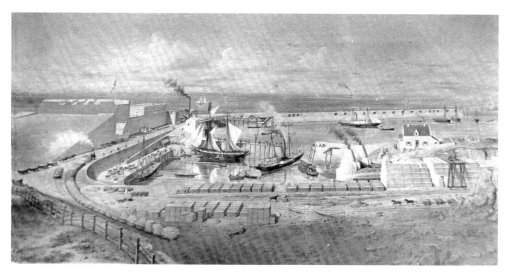

THE HARBOUR OF REFUGE AND FORTIFICATION WORKS at Alderney, painted and lithographed in colour in the Autumn of 1852 by G.S. Reynolds, and printed by M.&H. Hanhart. One of a series by this artist, another of which, painted two years later, is in the Queen's Gallery. A contemporary proof copy of the earlier engraving from which this photograph was taken is in the Alderney Museum. It was dedicated to the Breakwater Engineer, James Walker. It was also issued as a postcard around the turn of the century or possibly earlier.

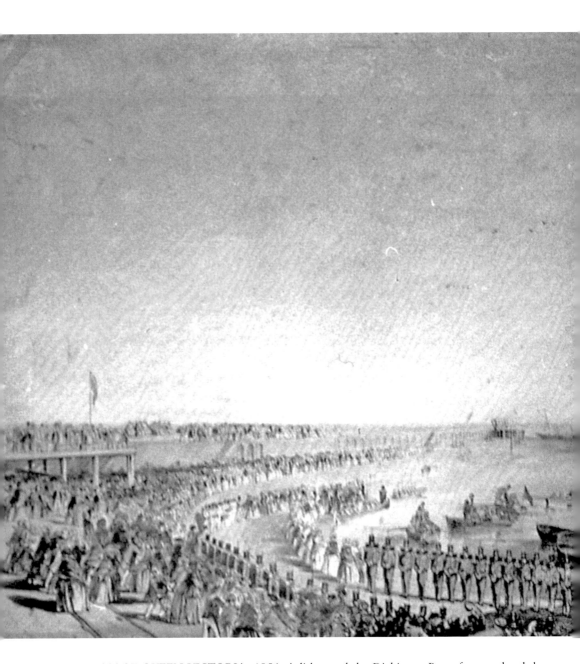

THE VISIT OF QUEEN VICTORIA, 1854. A lithograph by Dickinson Bros, from a sketch by Paul Naftel. This differs in minor detail, particularly of the ships, from the painting in the Royal Collection. The Royal Yacht, the PS *Victoria and Albert*, flying the Royal Standard, is towards the right of the picture, with HMSs *Black Eagle* and *Fairy* just beyond. The PS HMS *Dasher*

is in the centre. The queen is being greeted by the Town Major, Lt.-Col. William Le Mesurier, and the island officials. The queen later described Col. Le Mesurier in her diary as ' … a funny, good-natured old man, with a face like Punch'.

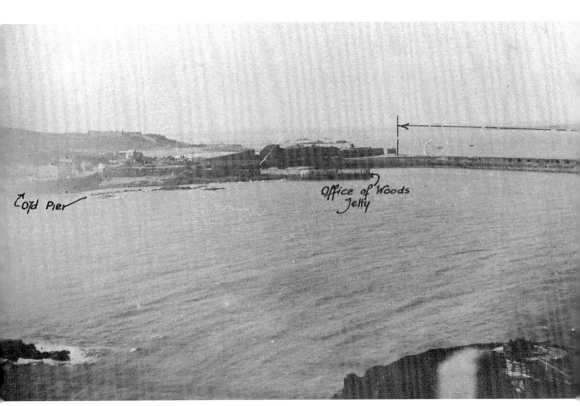

Cold Pier

Office of Woods Jetty

A PANORAMA OF THE BREAKWATER in March 1915, after a storm, by C.R. Le Cocq.

Longitudinal Sleepers & Rails

Sec 52

THE DAMAGE TO THE BREAKWATER WALL caused by the same storm, from the inside.

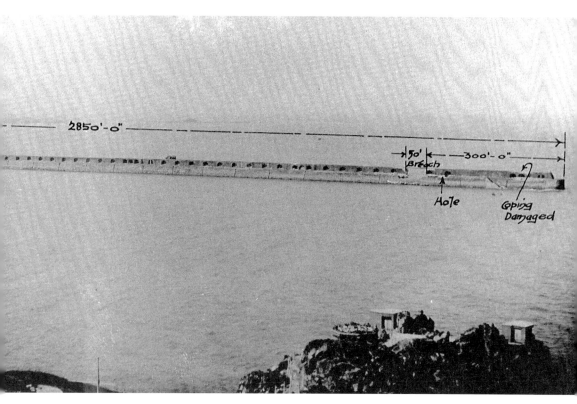

THE BREAKWATER, 29 November 1909. One of a long series of records made for the Government by C.R. Le Cocq. This picture shows the concrete blocks used as foreshoreing along the whole length of the seaward side.

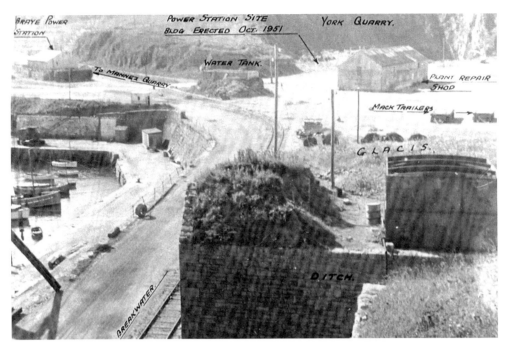

THE HARBOUR AREA WORKS in 1951. This picture was annotated later and taken just before the present power station was built.

THE STEAM CRANE ON THE BREAKWATER in 1951. This was finally retired in 1990, and is now being rebuilt by the Alderney Railway Society.

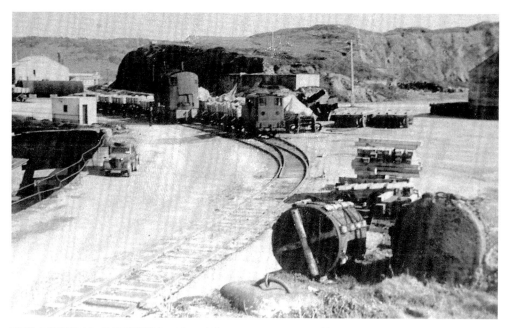

THE MINERAL RAILWAY in 1951. The steam engine *Molly* is nearest the camera, with the steam crane beyond.

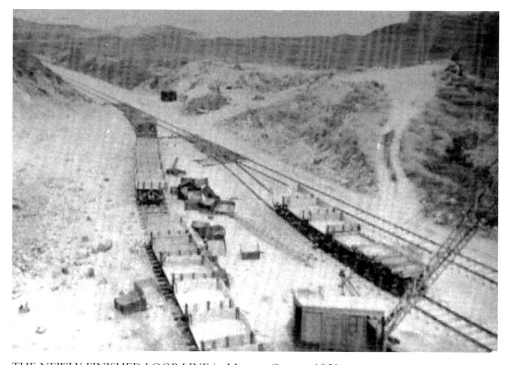

THE NEWLY FINISHED LOOP-LINE in Mannez Quarry, 1951.

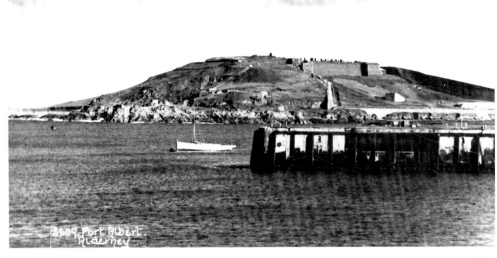

BRAYE BAY, with Fort Albert on the hill and the 1897 jetty in the foreground. A postcard by W. & E. Bailey, about 1930.

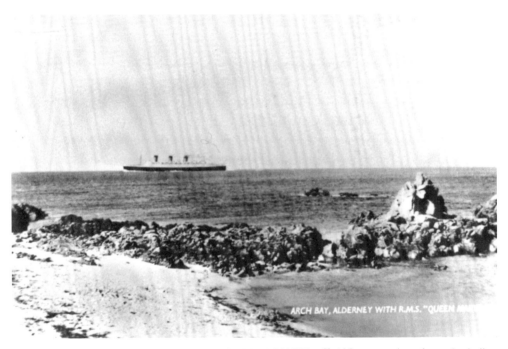

CUNARD LINES' ROYAL MAIL SHIP *QUEEN MARY*, off Alderney, taken from Arch Bay about 1950. The Cunarders passed close inshore regularly until the shipping lanes were changed in the 1960s.

SECTION TWO

The Forts

The Nunnery in Alderney has Roman origins, but much of it probably dates from the fifteenth century. The house inside was built by the Chamberlains in the 1560s, and the present gateway was made and the walls strengthened in 1793. It was known variously as Les Murs de Bas, Cazernes du Couvent and finally the Nunnery, but was never a religious building. The name was probably given to it by the soldiers in Napoleonic times when they were forced to live like nuns, a mile and a half away from the town and the local girls.

Essex Castle on the hill above was built between 1546-63, the 'pepper-pot' was added about 1812. The keep and part of the walls were demolished in 1850 to allow for the building of Fort Essex, intended as a military hospital with no gun batteries.

Various batteries, watch-towers and guardhouses were built around the island from 1550, with the majority being built between 1736 and 1804. The remains of several of these can still be seen. Longis Lines and the batteries there, Fort Doyle and Fort Platte Saline date from the later part of this period.

The remaining forts encircling the island were built between 1848 and 1858, several of them over the site of earlier fortifications, and also over neolithic burial grounds, most of which were completely destroyed in the process. Fortunately much of it was recorded by the Lukis family at the time, and their sketches, notes, and many of the artefacts found, including a hoard of over two hundred bronze weapons and utensils, are now in the Guernsey Museum. A copy of the Lukis's manuscript record of these finds is in the Alderney Museum.

FORT ALBERT AND FORT RAZ ISLAND, 1859.

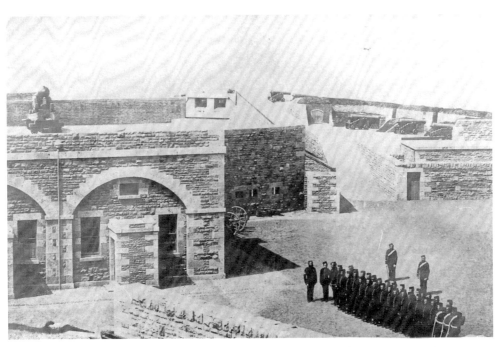

INSIDE FORT GROSNEZ, 1859. The Royal Alderney Artillery Militia are on parade.

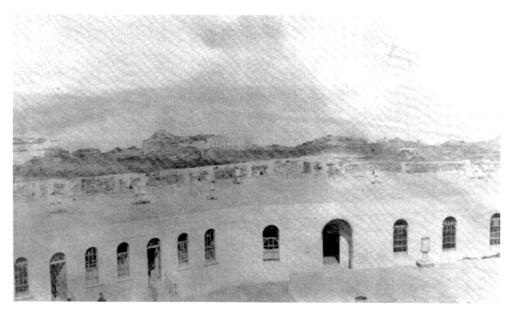

FORT ALBERT AND CHÂTEAU À L'ETOC in 1859.

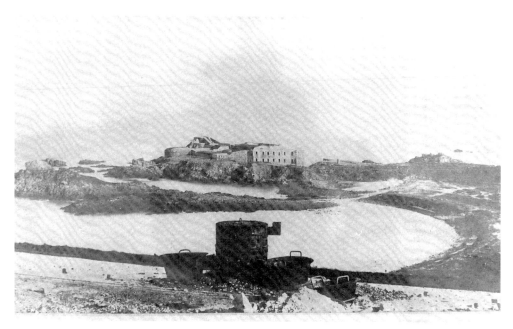

CHÂTEAU À L'ETOC AND SAYE BAY, in 1859. This appears to have been taken from the walls of Fort Albert, with a field kitchen in the foreground.

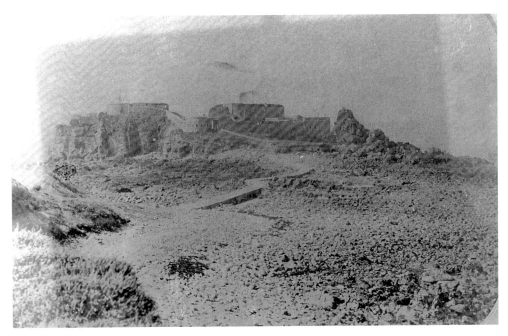

FORT CLONQUE, 1859

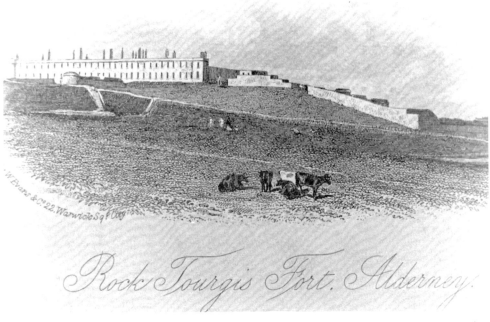

FORT TOURGIS in 1851. An engraving from a drawing by Louisa Lane Clarke printed in her guidebook.

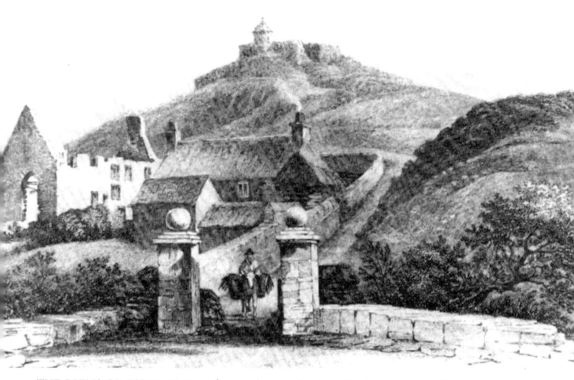

THE RUINS OF ESSEX CASTLE from a drawing by G.S. Shepherd, about 1830, engraved by J. Goodman, and printed in Robert Mudie's *The Channel Islands, a Topographical and Historical Guide*, published in 1840.

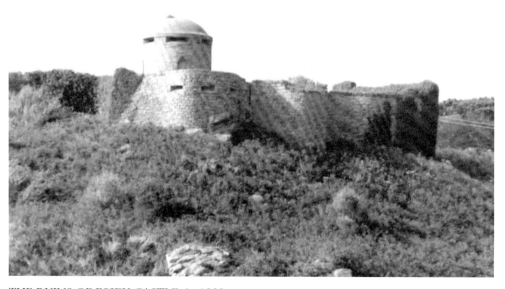

THE RUINS OF ESSEX CASTLE, in 1990.

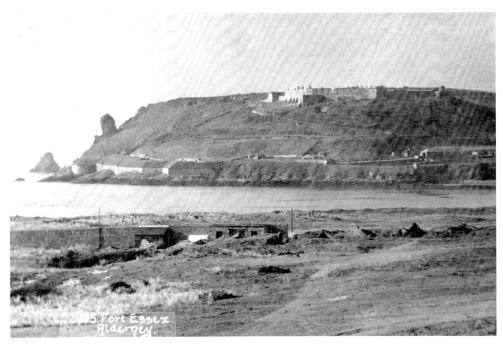

LONGIS BAY, with Essex Fort and Castle above, about 1930. Longis Lines are across the middle and the Rifle Butts in the foreground. The two rocks on the hillside are Les Roches Pendantes, or the Hanging Rocks.

FORT CORBLETS (right) and Château à L'Etoc (top) from Mannez Hill, probably about 1935.

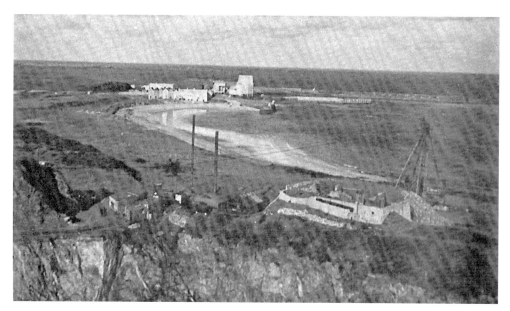

THF REMAINS OF BRAYE BATTERY, built in 1736, photograph taken in 1942. The harbour and the stone crusher are at the top of the picture. The tripod supports the cable for bringing up stone from Battery Quarry on the left of the picture.

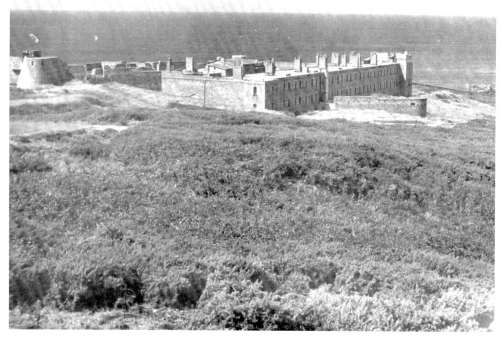

FORT TOURGIS JUST AFTER THE WAR, when it was still being used by the army.

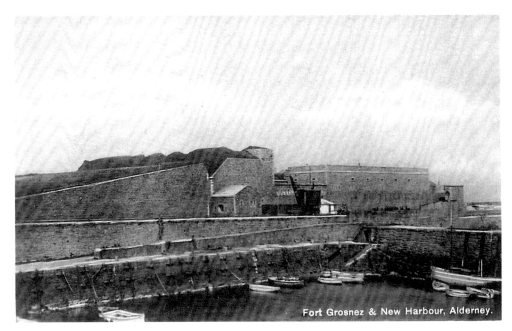

FORT GROSNEZ, about 1930.

THE INTERIOR OF FORT ALBERT in 1960. These buildings were later blown up, and have remained derelict ever since.

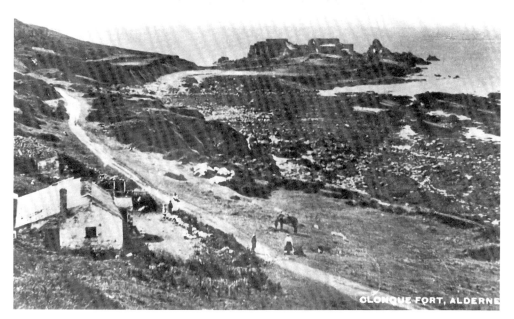

FORT CLONQUE AND CLONQUE COTTAGES. A Westness photograph from about 1900, taken at low tide.

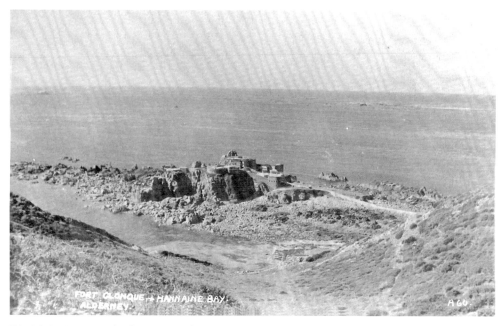

FORT CLONQUE, built 1851, and Hannaine Bay. From a postcard taken between 1948 and 1950.

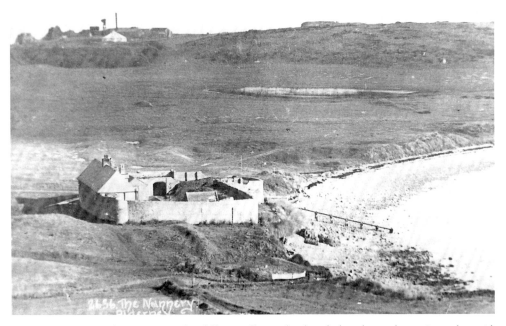

THE NUNNERY about 1930. The fallen wall on the beach has been there since the mid-eighteenth century. Sharp's Farm (the former Corblets Barracks) is top left, and Le Mare du Roe (King's Pond) or Longis pond (not dried up), right of centre.

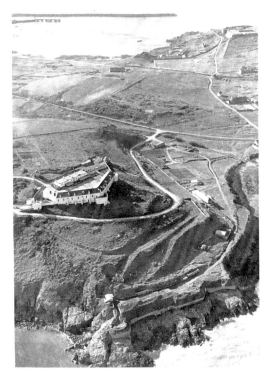

FORT ESSEX FROM THE AIR. The old 1790s battery, bottom centre, is known as the 'Frying Pan'. The Breakwater and the German jetty can be seen at the top of the picture.

St Anne's, Church, Town and Industries

The earliest town settlement in Alderney arose around the Bourgage, leading directly onto the agricultural land of the Blaye on one side and down to the principal spring, at what is now the corner of Little Street and Marais Square, on the other. The stream from here flowed across the present site of Marais and Connaught Squares, down Le Vallée to the sea at Platte Saline. The first church of St Marie was built on the mound (now the site of the Clock Tower), probably around 1100 and certainly before 1238 on the site of an earlier chapel or hermitage. This mound above the stream was possibly a pagan holy place long before that. The change of dedication of the church, to St Ann, was introduced about 1650-60, with the rise of Presbyterianism. (The name St Ann was used until the end of the nineteenth century. St Anne is used today.) The court was held in the open air in the churchyard until about 1740, and Le Huret was the traditional public meeting place where the start of vraic (seaweed) gathering and the dates of harvest were decided.

This area remained the principal settlement for centuries and most of the farmhouses were built here, with their backs into the bank behind them, and the farmyard entrances beside them.

Captain Ling, the Governor of Alderney in Cromwellian times, built his house (on the site of the Island Hall) in 1661; this later became the official Government House, and was rebuilt by later governors, the Le Mesuriers, in 1763. Rue des Héritiers, later to become New Street, and now known as Queen Elizabeth the Second Street was developed from about 1700, and had the '1720 House' at one end, and the first Court House, the Court of Heritage, built about 1740, at the other. Braye Road, and Victoria Street (formerly called Rue Grosnez, and before that La Rue des Sablons) arose after the harbour had been moved from Longis to Braye in 1736. Mouriaux House was built by the Le Mesuriers as their private residence in 1777.

High Street is an early nineteenth-century development, in line with what was possibly a Roman road up from Longis Bay.

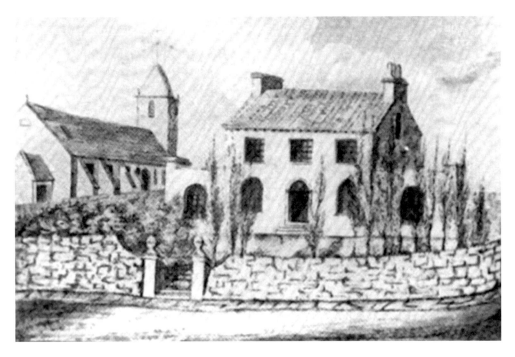

THE CHURCH AND PARSONAGE about 1830. From a drawing by Lt.-Col. William Le Mesurier, the Town Major about that time, who lived in Royal Square just opposite the Parsonage.

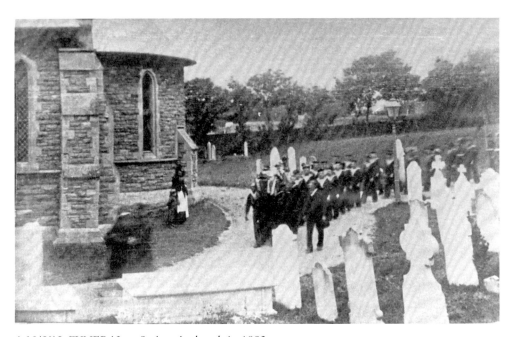

A NAVAL FUNERAL at St Anne's church in 1892.

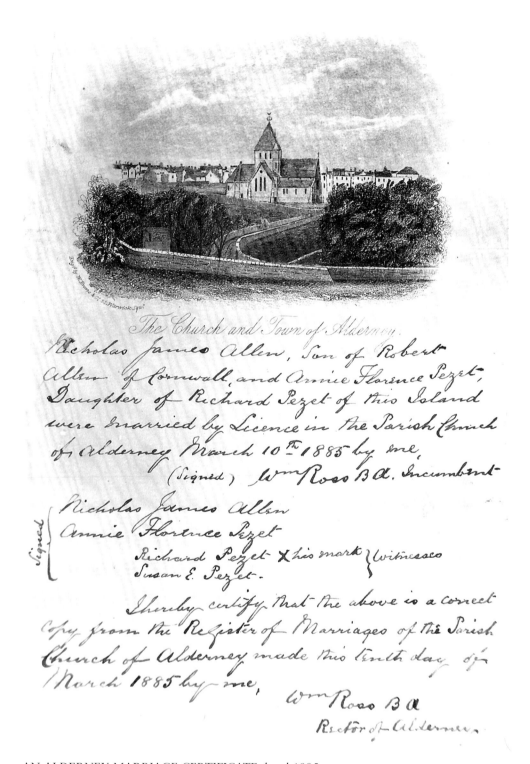

The Church and Town of Alderney.

Nicholas James Allen, Son of Robert
Allen of Cornwall, and Annie Florence Pezet,
Daughter of Richard Pezet of this Island
were married by Licence in the Parish Church
of Alderney March 10th 1885 by me,

(Signed) Wm Ross B.A. Incumbent

Nicholas James Allen
Annie Florence Pezet
 Richard Pezet ✗ his mark } Witnesses
 Susan E. Pezet.

 I hereby certify that the above is a correct
Copy from the Register of Marriages of the Parish
Church of Alderney made this tenth day of
March 1885 by me,

 Wm Ross B.A.
 Rector of Alderney.

AN ALDERNEY MARRIAGE CERTIFICATE dated 1885.

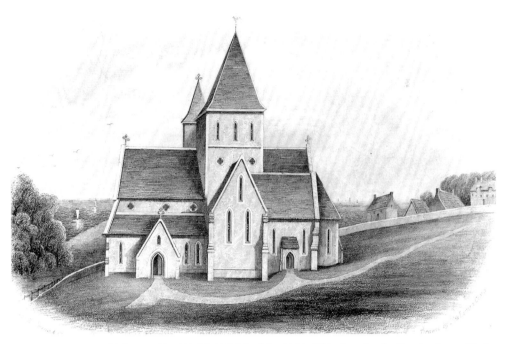

THE NEWLY BUILT CHURCH OF ST ANN [*sic*] in 1851. This drawing by Louisa Lane Clarke was engraved for her tiny *History and Guide to Alderney*, published in that year.

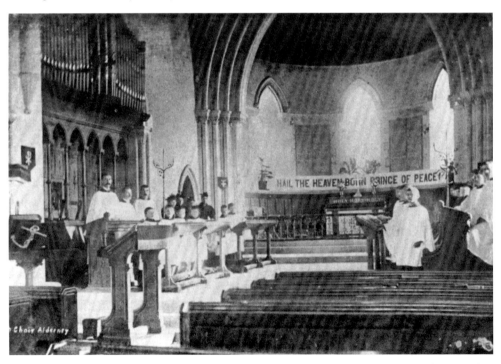

THE ALDERNEY CHURCH CHOIR AT CHRISTMAS, about 1900. A Westness photograph.

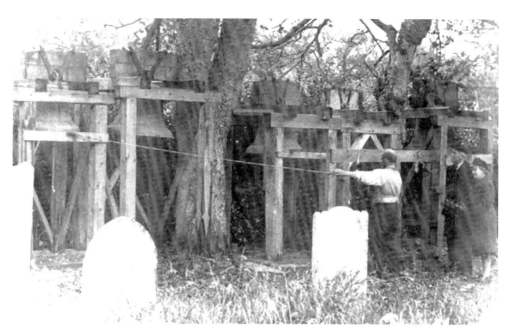

THE CHURCH BELLS WERE HUNG IN WOODEN FRAMES in the churchyard after they were recovered from France in 1946. They were rung by ropes until they were recast and rehung in the tower.

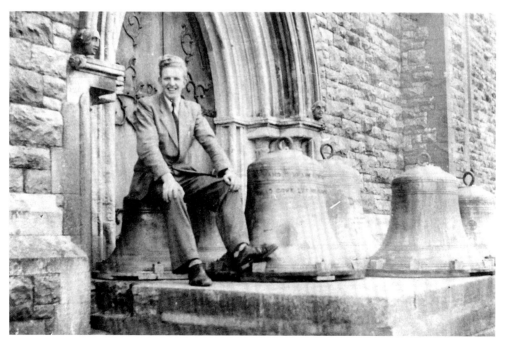

DAVID DUPLAIN WITH THE NEWLY RECAST CHURCH BELLS before they were rehung in the tower, about 1950.

INTERIOR OF THE METHODIST CHURCH, built in 1851, photographed about 1920.

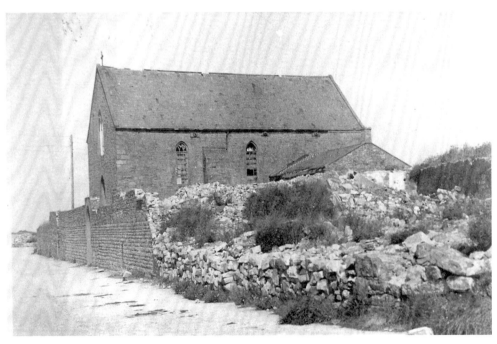

THE ROMAN CATHOLIC CHURCH AT CRABBY in 1946. The Germans used it as a store, and demolished the presbytery on the right to give a clear field of fire for a gun battery.

A BELL IS INSTALLED in the new Catholic church of St Anne and St Mary Magdalene, built in Braye Road, and completed in 1957.

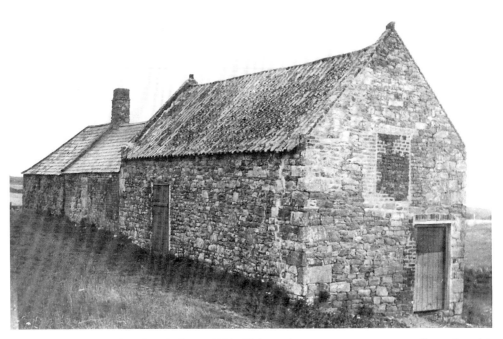

THE BARN AT ROSE FARM about 1930. This ancient structure was reputedly a chapel in medieval times.

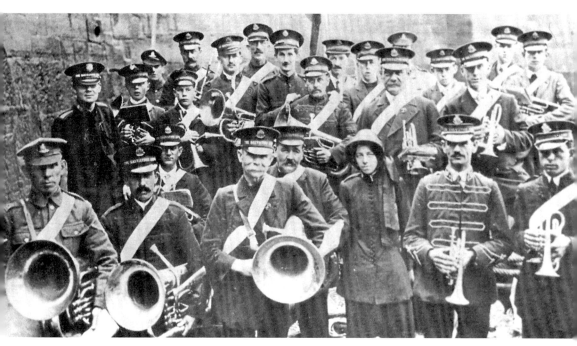

SALVATION ARMY BAND, 1920, on their way back from Guernsey. From left to right, front: RA L/Cpl. Jack Jardine, Billy Duplain, Walter Coombes snr, Jim Cleal, Mrs Tewkesbury, Fred Odoire (bandmaster), Wally Coombes (deputy bandmaster). Back: Drummer Tewkesbury, Vic Petit jnr, RA soldier, John McCarthy, Vic Petit snr, Bill 'Curley' Odoire, Charlie Brookes, Clarence Sebire, Tom Petit, Tom Chardine, Ray Clements, -?-, Reg Cleal (obscured), Richard Herivel, Bill Ollivier, -?-, -?-.

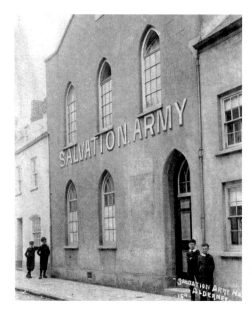

THE SALVATION ARMY HALL in High Street about 1920. This was originally built as a chapel for the Primitive Methodists in 1840.

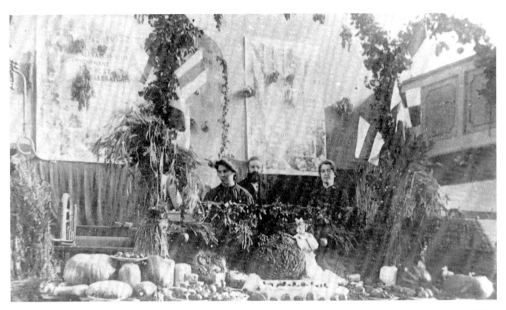

HARVEST FESTIVAL in the Salvation Army Hall about 1910. Postman James Ordoire and his son Fred are behind the stall.

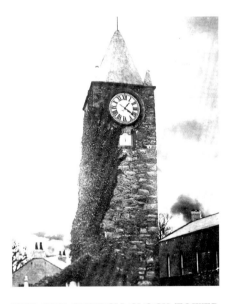

THE OLD CHURCH CLOCK TOWER about 1920. The bell tower was added to the church in 1790, and the clock installed in 1802. The remainder of the church was demolished in 1851/2, soon after the new parish church was completed.

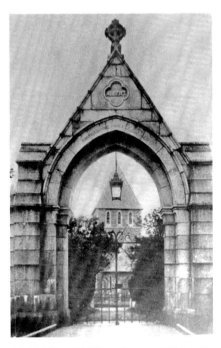

ALBERT GATE about 1900, by A. Heatley. This was erected in 1864 as a memorial to the Prince.

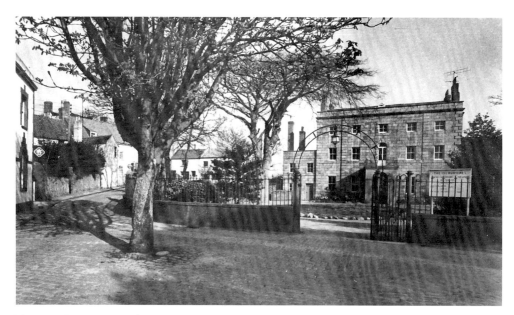

THE ISLAND HALL about 1950. Formerly Government House, and the residence of the Le Mesuriers in the late eighteenth and nineteenth centuries, it became a hotel in the 1860s run by Mrs O'Kelly, and was turned into a convent about 1880. The chestnut tree was planted by the Duke of Connaught in September 1905.

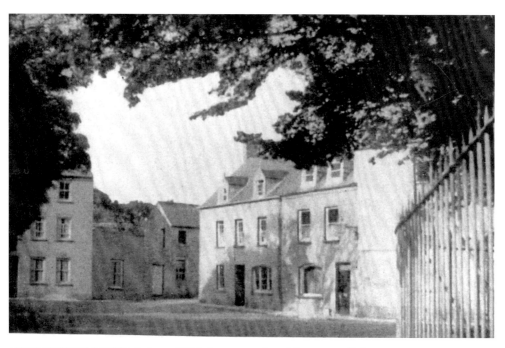

CONNAUGHT SQUARE about 1905, known as Royal Square until that year.

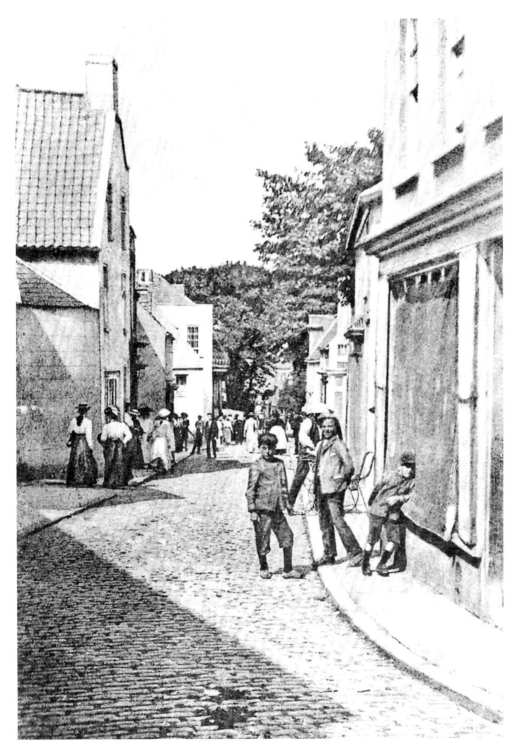

VICTORIA STREET about 1900.

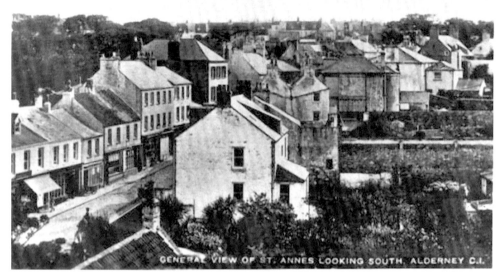

A VIEW OF THE TOWN, from the top of the Methodist church in 1900. A postcard made from a Westness picture.

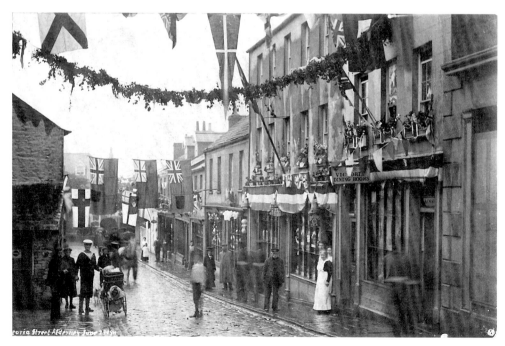

VICTORIA STREET decorated for the coronation of King George V, on 2 June 1911.

RIDUNA STORES about 1920.

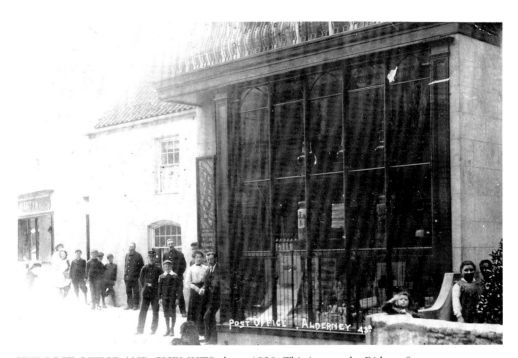

THE POST OFFICE AND CHEMISTS about 1920. This is now the Riduna Stores.

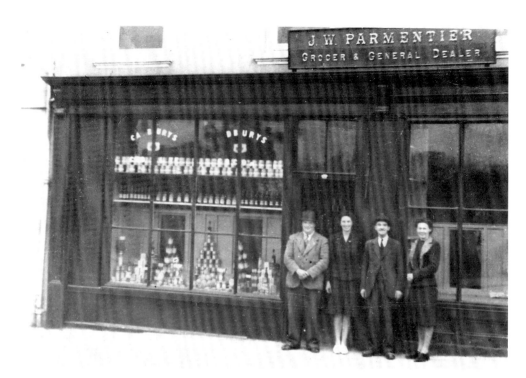

PARMENTIER'S SHOP at the bottom of Victoria Street in 1946.

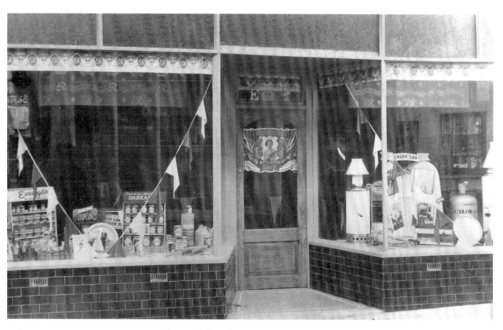

RALPH DUPLAIN'S SHOP in the middle of Victoria Street with decorations for the coronation of Queen Elizabeth II in 1953.

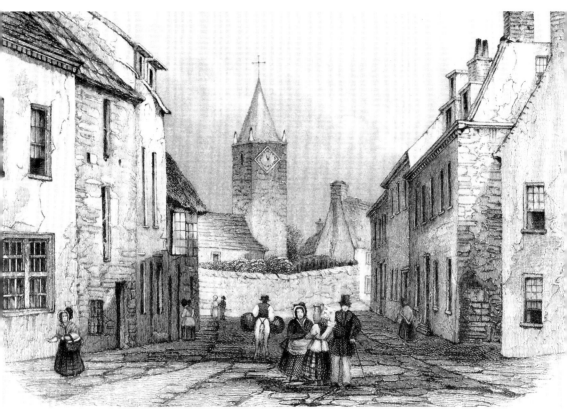

LE HURET between 1810 and 1830. A print from Robert Mudie's *Channel Islands*, published in 1840.

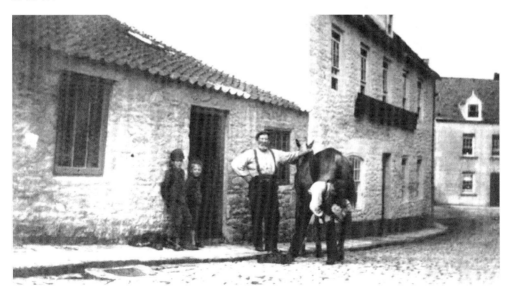

HARRY MAIN, THE BLACKSMITH at his forge in Le Huret about 1910.

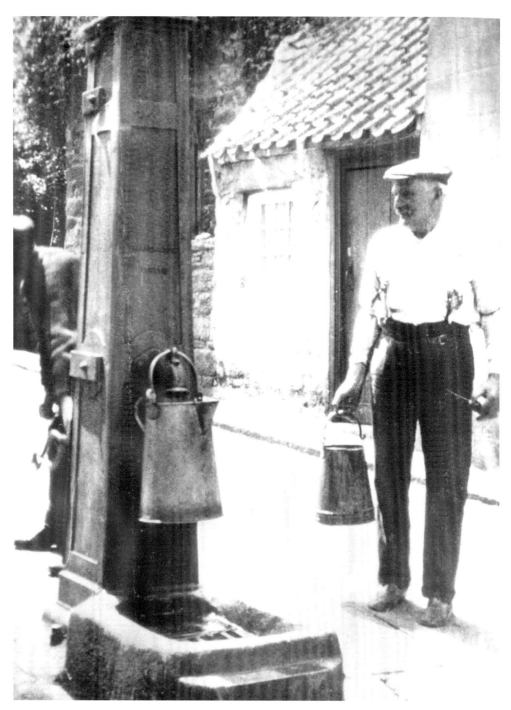

THE PUMP IN SAUCHET LANE, wrongly captioned 'The Bourgage' in this postcard of about 1930. The man with the pipe is Vic Pouteau, and the boy operating the handle is probably one of the Bohan family.

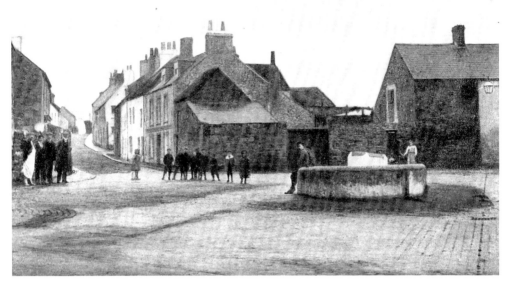

MARAIS SQUARE in about 1910. The large cattle trough was built about 1880.

YORK VILLA, home of Quarry-master Matt Rowe, 24 June 1924.

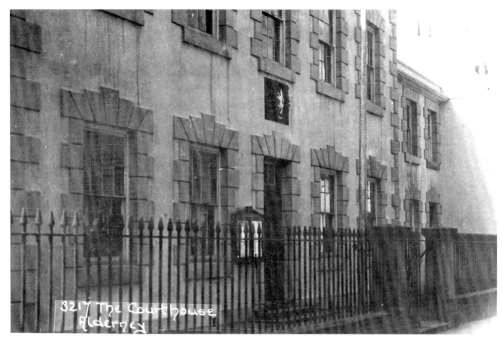

ALDERNEY'S COURTHOUSE about 1930. A postcard by W. & E. Bailey.

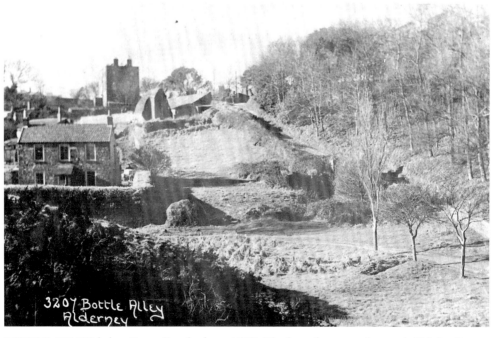

BOTTLE ALLEY, below Braye Road, about 1930. The large house at the top is Val des Portes, now the home of Alderney's President.

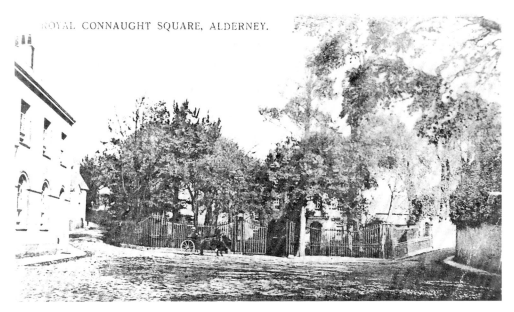

ROYAL CONNAUGHT SQUARE. The postmark on this card is 1905, the year the name was changed.

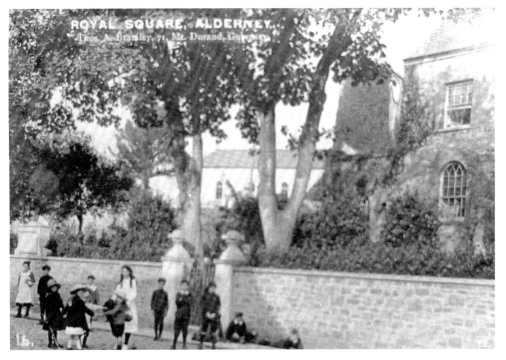

ROYAL SQUARE (Connaught Square) about 1900. The children are in front of the vicarage, with the school behind.

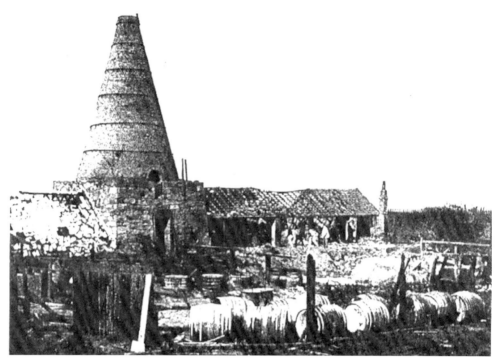

HELCKE'S EXPLOSIVES WORKS at the top of the Allées ès Fées. It was destroyed in an explosion on the evening of 10 September 1903, after a spirit store was struck by lightning. This picture was taken just afterwards. The works manufactured fulminate of mercury for detonators and also supplied it to the British Navy for use in torpedos. The fire engines from Forts Albert and Tourgis attended, but were unable to assist. No one was hurt.

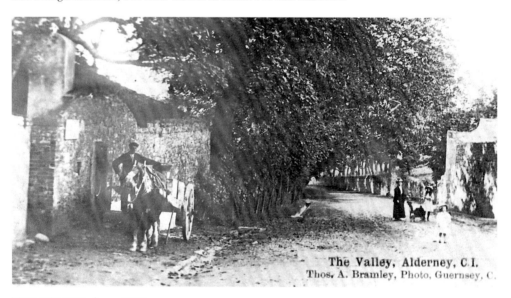

THE VALLEY about 1920.

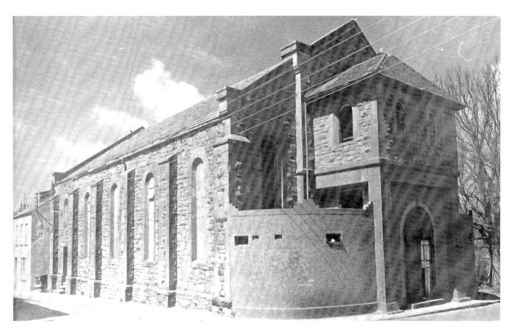

THE LYCEUM CINEMA at the junction of High Street and Le Val in 1946. Built in 1840 as the Scottish Presbyterian church, it was later turned into a skating rink and dance hall, and was known as 'The Rink'. It was also used as a cinema when moving pictures arrived. The Germans turned it into a luxury cinema during the war. It later fell into disuse, and was demolished about 1970.

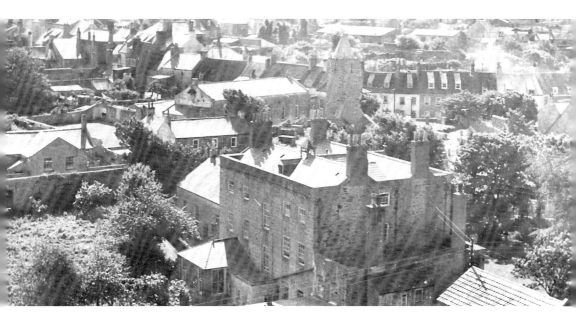

A VIEW OF ST ANNE from the top of the German water tower in Les Mouriaux, about 1950. The Island Hall is in the foreground with the old church tower and the school behind it.

BRAYE STREET with the Sea View and Diver's Inns about 1890. John Wesley inadvertently spent a night here in 1787, when driven into Alderney by a storm, while on his way to Guernsey.

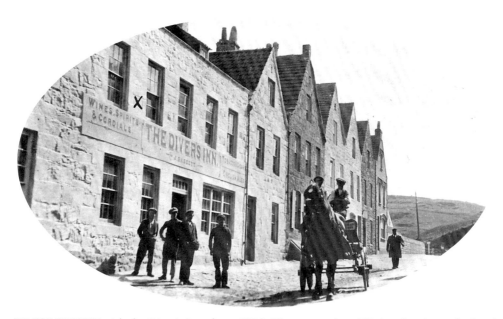

BRAYE STREET with the Diver's Inn about 1920. The room where Wesley slept is marked with an X.

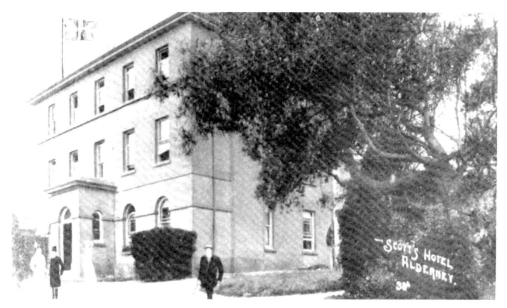

SCOTT'S HOTEL IN BRAYE ROAD about 1890. Built about 1855, Scott's was owned by Captain Scott, who ran the paddle-steamer service between Guernsey and Alderney, and was run by his wife. It was burnt down in 1924.

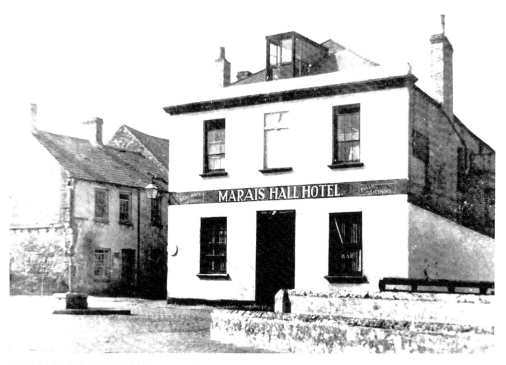

THE MARAIS HALL HOTEL in 1945.

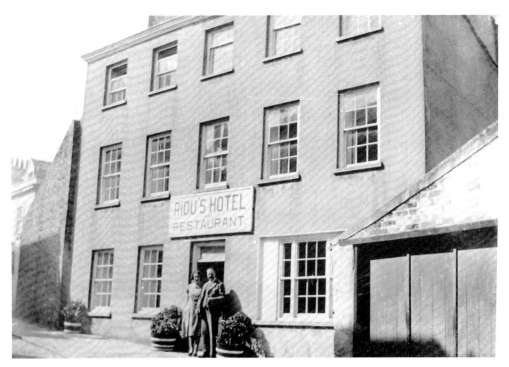

RIOU'S HOTEL IN VICTORIA STREET (formerly the Commercial Hotel, and now the Georgian House) about 1930.

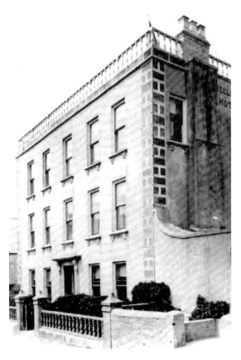

THE BELLE VUE HOTEL about 1920.

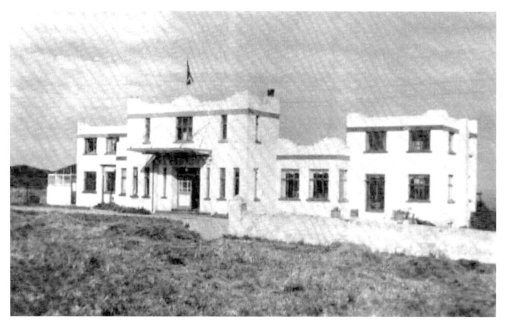

THE GRAND HOTEL on Butes in 1947. Opened in March 1937 and managed by air ace and King's Cup winner, Tommy Rose. Known as the Grand Island Hotel in the 1970s, the Grand was totally destroyed by fire on 20 March 1981.

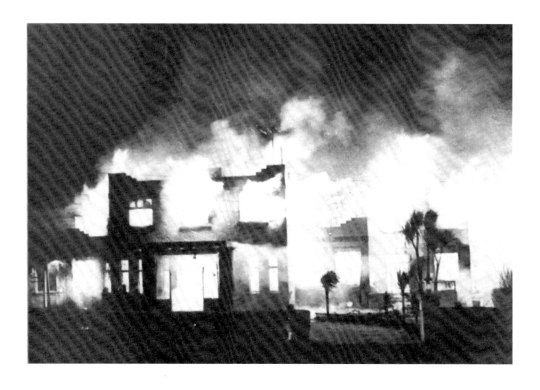

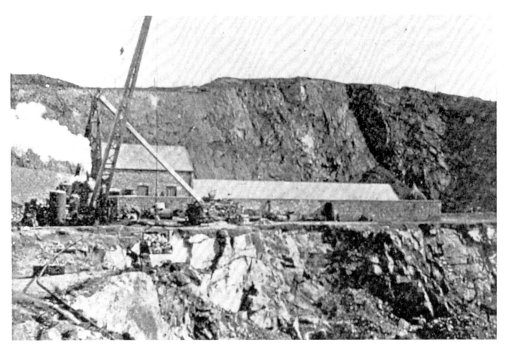

YORK HILL QUARRY about 1900. A postcard by A. Heatley. The electricity generating station now occupies this site.

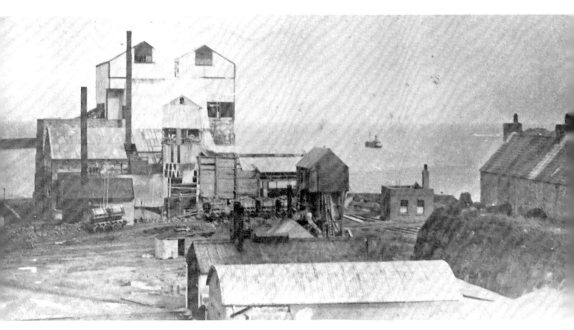

THE NEW STONE CRUSHER erected near the harbour for Mr Brookes in 1905. English Row is on the right and the maintenance sheds for the railway engines are in the foreground.

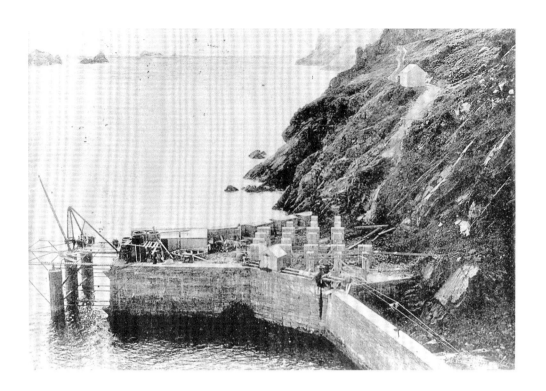

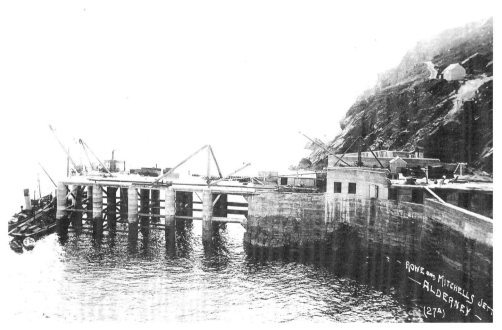

BUILDING THE CACHALIÈRE PIER in 1904 in preparation for the opening of the granite quarry.

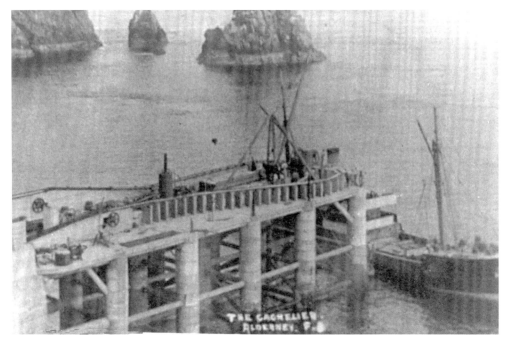

THE COMPLETED CACHALIÈRE PIER about 1910. The steamer loading is probably the SS *Tyne*, which sank after hitting nearby Bonit Rock in January 1922, with the loss of several lives.

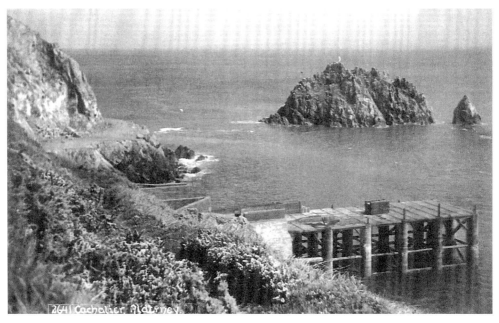

THE ABANDONED CACHALIÈRE PIER around 1934. The loading gear, and most of the machinery, was dismantled when the quarry closed in the '20s.

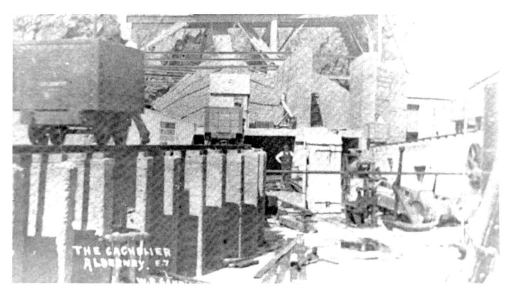

THE LOADING MACHINERY AT CHACHALIÈRE about 1910.

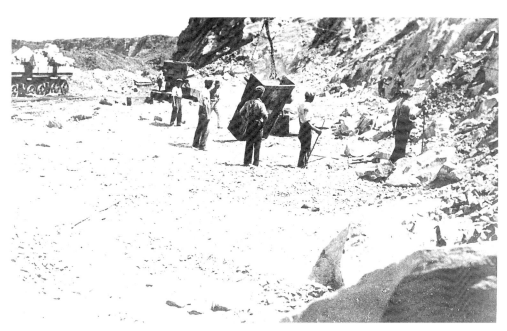

GUERNSEY QUARRYMEN working in Mannez Quarry, quarrying stone to repair the Breakwater in 1942, during the German occupation.

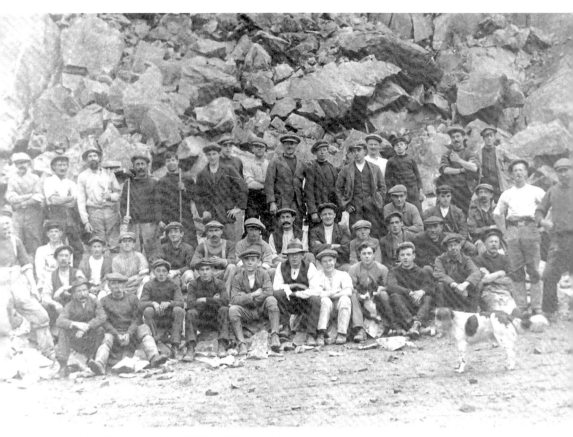

MATT ROWE'S QUARRY WORKERS in Mannez Quarry about 1900. It has not been possible to identify them all, but the group includes members of the Dupont, Simonet, Bleistel, Goring, Langlois, Harvey, Bichard, Baker, Newton, Randal, Godfray and Clarke families.

SECTION FOUR

The People of Alderney

In any book of photographic memories, the people inevitably form the most important section. Many of the persons depicted in these photographs of islanders at work, at play, taking part in important functions, and in their homes, are long dead.

It has not been easy to identify some of them. Family albums rarely seem to have much information in them. The person who stuck the photographs in the album knew all of the subjects at the time, and often not even a date is given.

In this section are included school groups, sports and social events, important national events, individual photographs of various island officials and personalities, and simple family 'snaps'.

Alderney Week is the island's traditional holiday week. Alderney still keeps the bank holiday on the first Monday in August, which makes it almost unique. Around the turn of the century, sports events and competitions, football, cricket, shooting and golf matches, and horse racing, between the islanders, the Militia, and the regiments in garrison in the forts, became an annual event; at various times between June and September. These often concluded with a bonfire or carnival. This was later combined with the annual cattle show in May or June, and after the Second World War, when it was revived in 1948, became a week of festivity, starting with a church service. A beauty queen, Miss Alderney, is elected and carnival floats, dog and pony shows, concerts, and swimming and boating competitions are held, all ending up with a torchlight procession through the town to the Butes, where a huge bonfire is lit sometimes followed by a firework display.

This torchlight procession probably has its origins in pagan fertility rites in spring, which later became the custom of Les Brandons, *held on the first Sunday in May, and later also to celebrate the harvest. The young people of the island used to repair to Clonque islet to sing and dance round a fire, and came home late at night by torchlight, waving torches made of twisted rushes, to the considerable danger of the thatched roofs.*

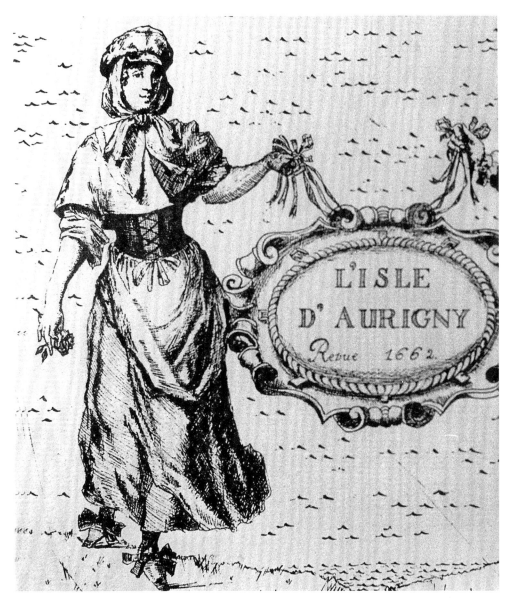

DRESS OF THE ALDERNEY PEASANT WOMAN, taken from a French map of Alderney dated 1662. The women used to keep watch at the beacons while their men were working in the fields, and at various times, when Alderney was threatened with invasion by the French, were reputed to have walked up and down on the cliffs in their red petticoats and shawls, to make the enemy think they were British Redcoat soldiers. The ruse appears to have worked. Their traditional dress consisted of a round cap of stiffened white linen, put on and off like a man's hat and fastened under the chin with a bow of black ribbon or a gold hook, a red cape or shawl, a black gown rolled up and tucked into the pockets of the red cloth petticoat, blue stockings and black shoes with silver buckles.

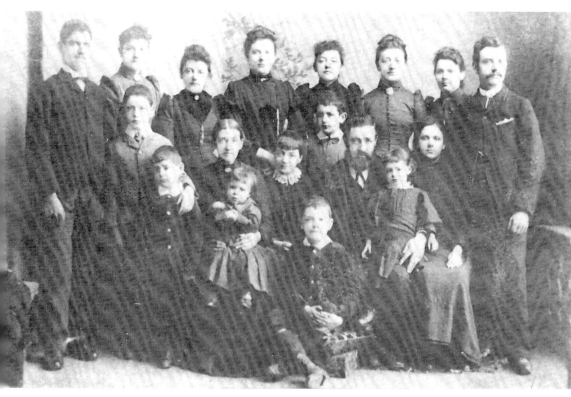

THE FAMILY OF POSTMAN JAMES ODOIRE about 1885. He had seventeen children. From left to right, back row: Jimmy, Maggie, Jane, Harriet, Eliza (Simon), Annie, Mo, Jack. Second row: Willie, Alfie. Front row: Fred, Mrs Odoire with Mabel, Nellie, Mr Odoire with Lil, Eliza (Lizzie Rowe). Ted is in front. Mary was missing from the picture.

JUDGE LE COCQ about 1895. He was judge from 1892-7, when he resigned over the new jetty issue. His portrait hangs in the States' chamber.

ALDERNEY'S FIRST UNIFORMED POLICEMAN, Tom Lihou. His wages in 1898, when this photograph was probably taken, were 12s. 6d. a week.

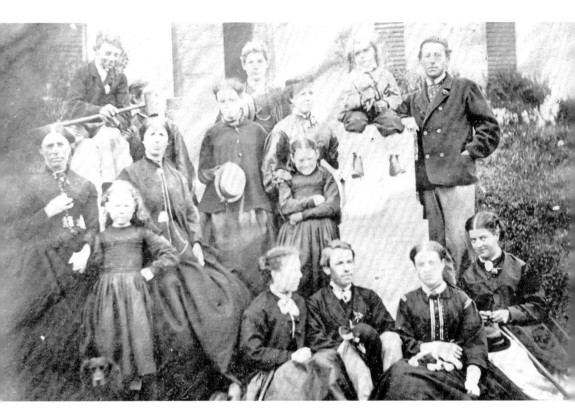

AN ALDERNEY FAMILY In June 1867. Does anyone know who they were, or where in Alderney this picture was taken?

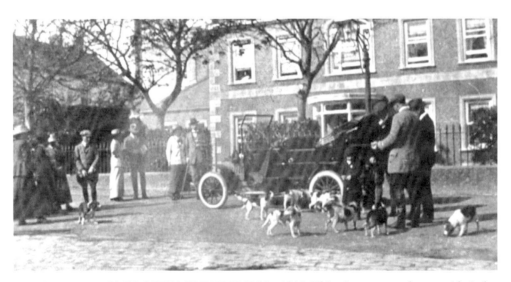

THE ALDERNEY PACK OF BEAGLE HOUNDS In 1912. This picture was taken outside Judge Mellish's house at Les Roquettes. The house is now the Roman Catholic Presbytery.

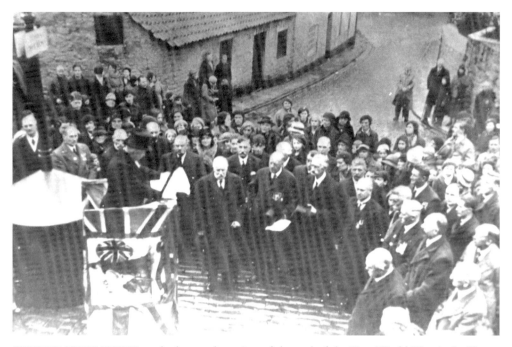

SHERIFF JOHN PEZET reads the proclamation of the end of the First World War, in Le Huret, in November 1918. From left to right in the front row: Capt. Marriette, Charles Richards, a child, Dan Le Cocq, Major Langlois, Judge Mellish, with Billy Mignot just behind on his right; Nick Gaudion, Jimmy Herivel, -?-, -?-, -?-, -?-, Harry Catts from Rose Farm. Second row from right-hand end: Norman de Laune, Charlie Bichard, John Parmentier. Third row, extreme right: Peter Main, the blacksmith.

DR LOW, ALDERNEY'S DOCTOR, in 1912. He had his office in Sauchet Lane, and charged 2s. 6d. a visit.

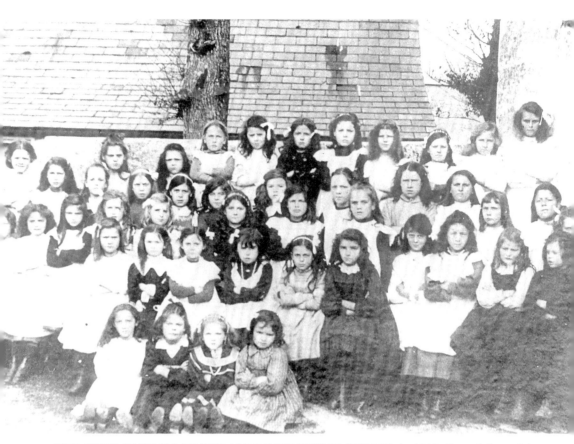

THE GIRL'S SECTION OF THE ALDERNEY PUBLIC SCHOOL in 1912. From left to right, back row: Winifred Rowe, Clarie Rowe, -?-, Barbara Marsh, Miriam Oliver, May Gaudion, ? Oliver, May Parmentier, Nellie Squires, Lilian Langlois. Next row: Violet Church, Gladys Bassett, -?-, Vivia Le Cocq, -?-, Alice Coombes, May Oliver, Dolly Sykes, ? Langlois, Mabel Le Vallée. Third row down: -?-, -?-, ? Blondin, Mildred Major, Christine Riou, ? Oliver, Kazia Catts, Christine Basset, ? Church. Fourth row down: Lilian du Bois, Elsie Coombes, Olive Tewkesbury, Edie Randal, Olive Le Vallée, Elsie Blondin, -?-, Elsie Burland, Marion Burland. Front row: Rita Pelham, Elsie Angel, -?-, ? Blondin.

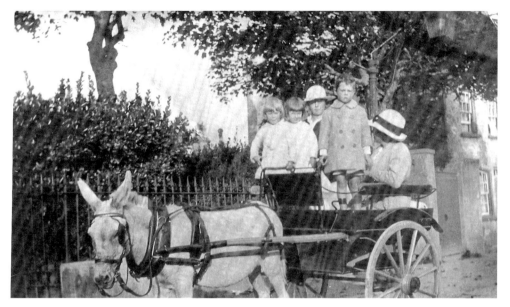

THE MELLISH FAMILY outside the judge's house in Les Rocquettes, about 1920. From left to right: Jean, Peggy, Alice, Michael, Lily. The donkey was called Mrs Blétel.

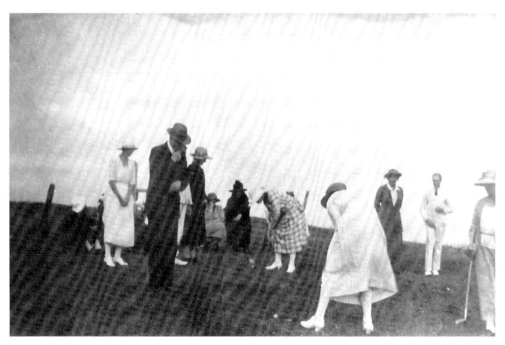

JUDGE MELLISH'S FAMILY, and others, playing golf on the course behind Fort Albert in 1922.

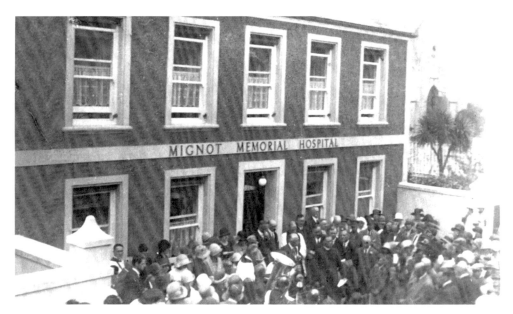

THE OPENING OF THE MIGNOT MEMORIAL HOSPITAL In Victoria Street in 1926. The building was converted from the former Victoria Hotel which had moved across the street. It is now the Boutique and Rediffusion shops.

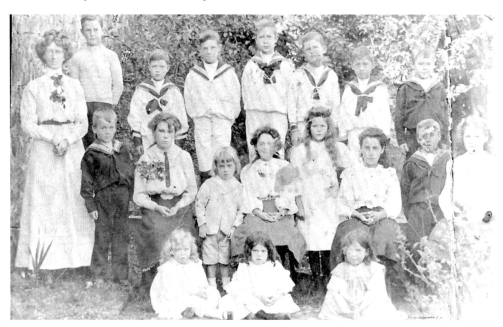

MISS EMILY HERT'S PRIVATE SCHOOL in Braye Road, probably about 1920. She later became Mrs Christie, and was still running the school until the island was evacuated in 1940. From left to right, back row: Leslie Gaudion, ? Sherwell, Roland Gaudion, Jim May, ? Shenvell, Aubrey Saunders. Middle row: Samuel Saunders, Nora May, ? Saunders, Queenie Toy, Maggie Blackmore, Florence Tourgis, John Saunders, Maud May. Front row: Stella May, Ida Blackmore, -?-.

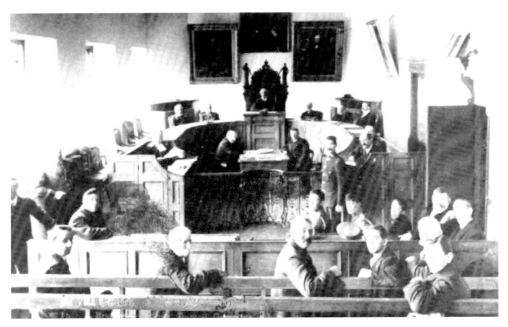

THE ALDERNEY COURT in 1919. The policeman is Joe Workman.

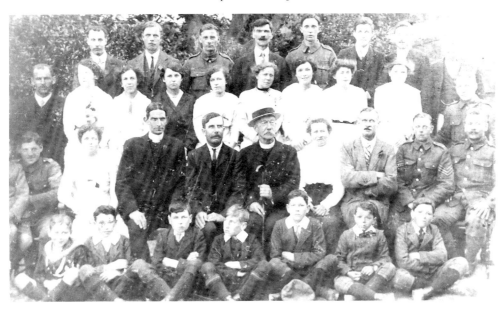

REVD LE BRUN AND THE ALDERNEY CHURCH CHOIR in 1915 or 1916. From left to right, back row: Frank Hammond, Harold Mignot, soldier, Joe Workman, soldier, Billy Parmentier, J. Herivel, Thomas Le Cocq. Next row: Charles Renier, Marjory Mignot, Lois Martyn, Mini Baron, Edie Richards (née Sebire), Alice Le Cocq, Emmy Sumner, Queenie Toy, soldier. Seated: soldier, Maggie Sebire, Revd Price (curate), Billy Mignot, Revd J. Le Brun (vicar), Mrs T. Toy, Harry Peake (schoolmaster & organist), two soldiers of N. Staffs. Regt. Front row: Lennie McLernon, Billy Sumner, H. Le Cocq, Claude Peake, Fred McLernon, Harold Renier, Ernie Renier.

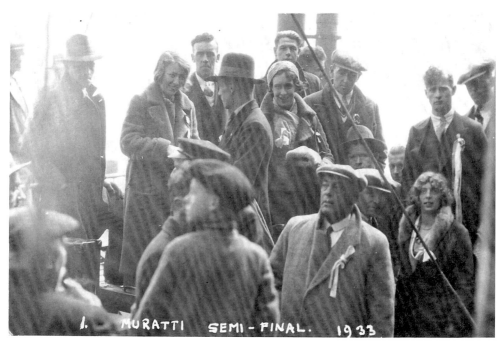

ALDERNEY 'NORTHERN LIGHTS' SUPPORTERS en route for Guernsey on SS *Courier*, for the Muratti Vase soccer final in 1933. Left to right, back row: -?-, Maisie Hammond, Jack Hammond, -?-, Babs Hammond, Peter Catts, -?-, Alfie Duplain, -?-. In front: Alf Després, Dan Anquetil.

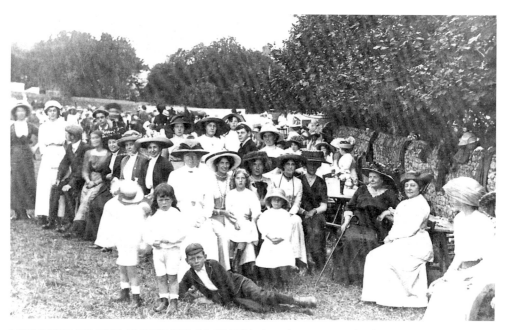

LISTENING TO THE ALDERNEY ORCHESTRA at the 1910 Cattle Show.

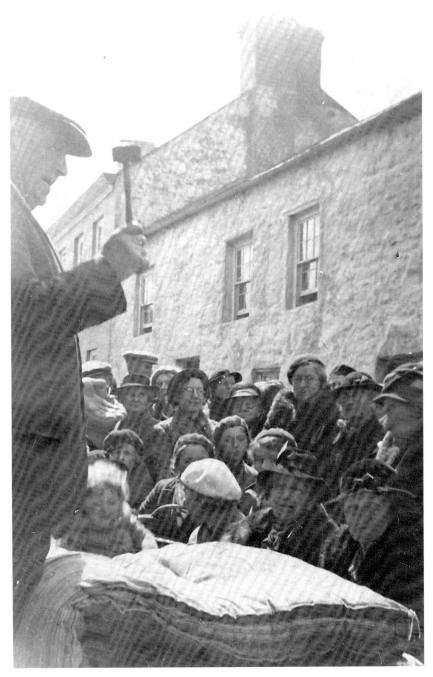

SHERIFF JOHN PEZET conducting an auction in Le Huret, about 1930. From left to right, front row: baby, -?-, Mrs Benêt, Mrs Bessie Duplain. Middle row: -?-, -?-, -?-, Maggie Benfield jnr. Back row: Mrs J. Parmentier, -?-, -?-, Mrs McMunn, Mrs Toy.

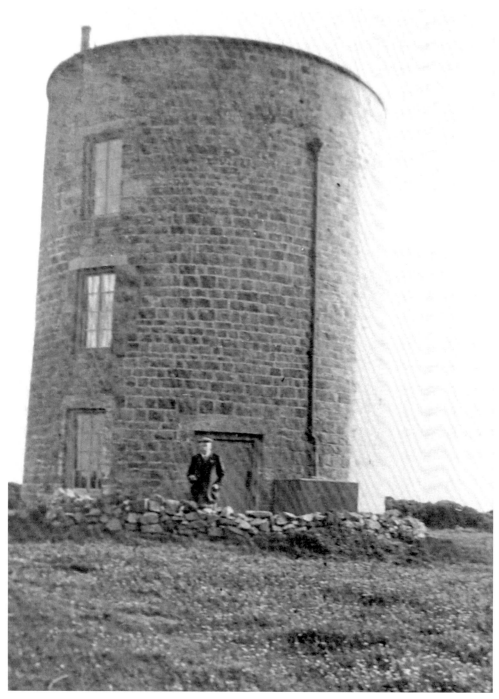

TELEGRAPH TOWER was built in 1810 by Mr Mulgrave to house a semaphore for communication with Guernsey and Sark. This photograph, taken in 1936, includes Bill Hammond, licensee of the Campania Inn.

YORKSHIRE AND ALDERNEY GIRL GUIDES, about 1925, taken in the garden at 'Balmoral'. The Yorkshire girls are in the pale hats. Others, from left to right, back row: Janet Le Cocq, Lilian Odoire, Vivia Le Cocq. Seated: Revd J. Le Brun, -?-, Ada Odoire, -?-, Mrs Mellish, -?-, Mrs Le Brun, Mrs Le Brun jnr.

THE MAYDAY CELEBRATIONS On Butes about 1920. This custom was re-enacted by children in the dress of the period in Alderney Week, 1937.

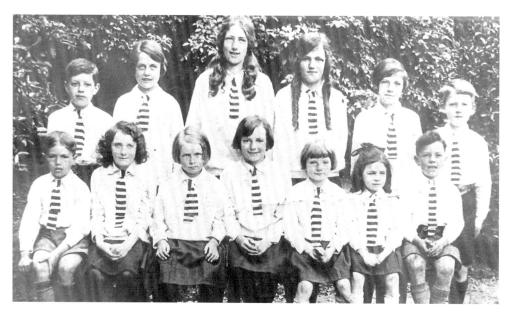

THE CONVENT SCHOOL PUPILS, about 1935. From left to right, back row: Joey Goasdue, Edith Macdonald, Esmé Baron, Florence Collenette, May Sumner, ? Benfield. Front row: George Baron, Doreen McMunn, Pauline Beale, Lillian Collenette, Joan Holman, Catherine Sebire, Tommy Oliver.

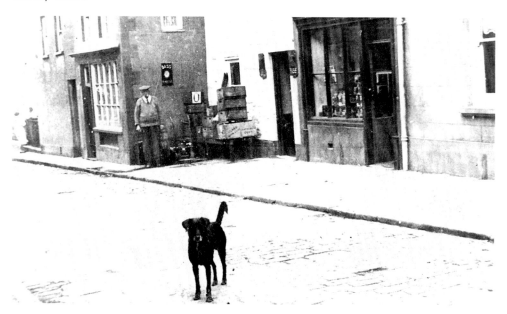

BILL HAMMOND (AND A DOG) OUTSIDE HIS CAMPANIA INN in High Street, 1937. He first opened the pub in 1898, when his brother Frank had to hold the licence as he was still serving as a Sgt. Maj. Instructor in the RA in Alderney. He continued as licensee until the evacuation in 1940, and his sons ran the pub after the war, until the 1970s.

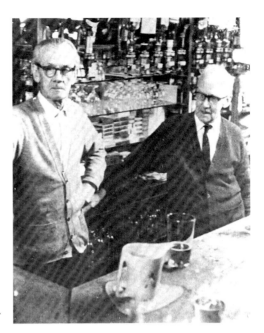

THE HAMMOND BROTHERS, Jack and
Bert, at the bar of the Campania in about 1948.

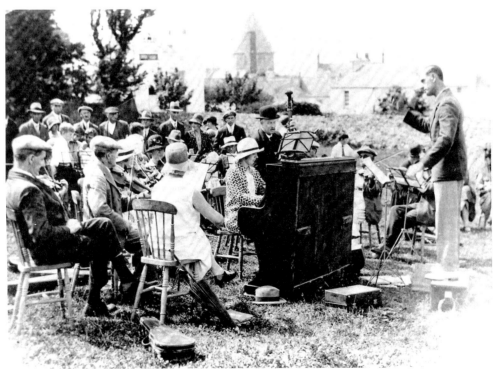

THE ALDERNEY ORCHESTRA AT THE CATTLE SHOW, 30 July 1928. From left to right:
Ted Odoire, Jim Cleal, Cathleen Odoire, Eliza Simon, Liza Després (back to camera), Lil Odoire
(piano), George Simon (bowler hat), Fred Odoire (conductor).

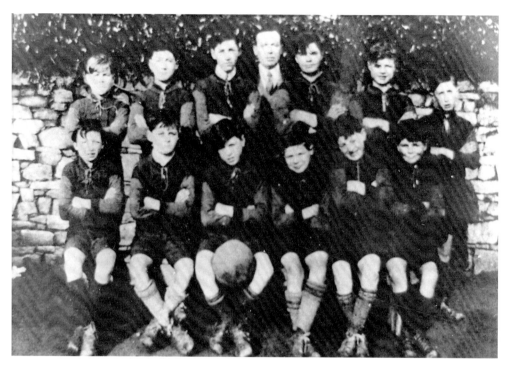

ALDERNEY PUBLIC SCHOOL BOYS' FOOTBALL TEAM about 1935. From left to right, back row: -?-, Teddy Odoire, Reg Simon, schoolmaster Mr Collins, ? Du Bois, -?-, Mervyn Kitts. Front row: Harry Bridel, ? Maclean, 'Busty' Allen, George Caplain, Freddy Odoire, Harry Quinain.

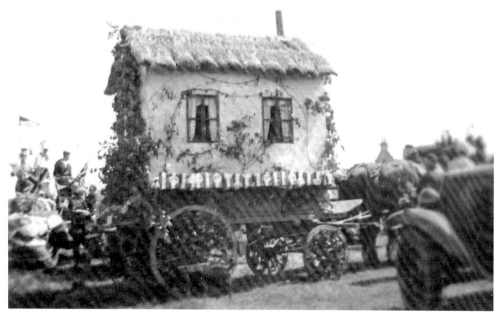

AN ALDERNEY WEEK FLOAT, 1937.

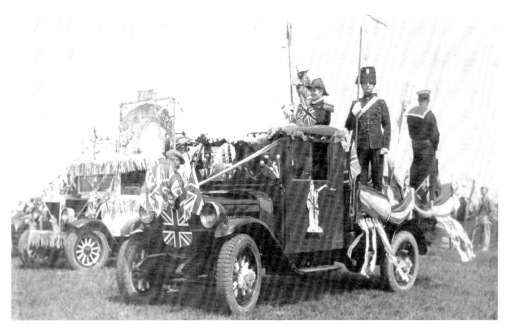

ALDERNEY WEEK, 1937. The uniforms on this float were from postmaster Capt. Marriette's collection. From left to right: Teddy Odoire in uniform of 17/21 Lancers, Maureen Riou in naval officer's uniform, Fred Odoire in uniform of 7th Hussars, Nick Allen as a sailor.

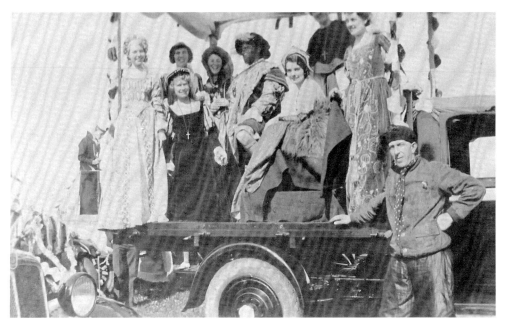

THIS FLOAT HAD THE THEME OF HENRY VIII AND HIS SIX WIVES and was devised by the Odoire family. From left to right: Doris Mackey, Wilma Le Cocq (Doris Brehaut behind), Arthur Allen, Lilian Audoire, Helen Odoire as the cardinal, Kathleen Odoire, Dick Main.

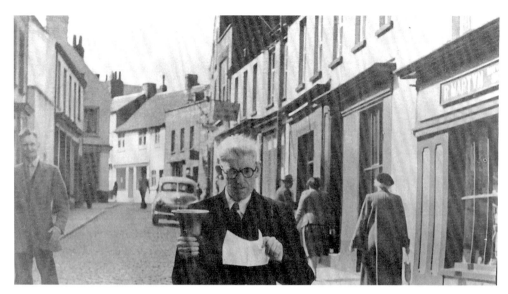

THE TOWN CRIER in Victoria Street in 1948. This picture was used as an illustration in an article written by Alderney resident Tim White (later creator of the musical *Camelot*) for an American magazine.

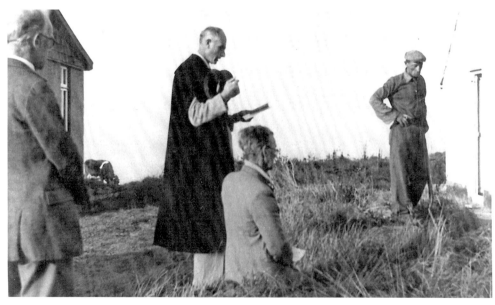

RAISING THE *CLAMEUR DE HARO* over a boundary dispute on 15 October 1956. Bert Hammond kneeling makes the ancient cry, against Mr Pollock-Smith, in the presence of the Clerk of the Court, Peter Radice, with Jack Hammond and a workman as witnesses. This has the immediate effect of a High Court injunction for a year and a day, if properly registered at the Alderney Court within twenty-four hours. It was the first time since the war that it had been raised.

SECTION FIVE

Alderney Agriculture

The Grande and Petite Blayes have been Alderney's two main, open-field agricultural areas, probably since the ninth century. They were farmed communally on a block system, which was much divided into strips by inheritance. They were planted year after year in corn, without much rotation of crops, until the late eighteenth century, when potatoes began to be grown as a crop as well. Their fertility was maintained by annual applications of vraic or seaweed, collected at two main times at the lowest equinoctial tides, and also in the annual banon *between harvest and sowing, which involved turning the cattle and sheep loose in the area.*

The whole area was surrounded by an earth and stone bank topped by furze known as a costière, *much of which can still be seen on the north side of the old road running along the south side of the island round the airport, and further to the east.*

The individual holdings were marked by stone boundary markers, many of which were removed during the Occupation, and later replaced by the land commissioners in the 1950s. Much of the Grande Blaye is now beneath the airfield.

Some twenty-five to thirty abreuvoirs publiques *(always written 'publics' in Alderney Court Records); or drinking troughs, were provided around the island for the cattle, mostly built during the 1880s and '90s, at the sites where springs had become the traditional watering places.*

There were two windmills, one originating from before 1238, and the other, the 'New Mill'; built in 1560, and probably rebuilt in 1760. Both were situated on the Grande Blaye. Le Vieux Moulin, on the rise near the site of the Telegraph Tower, was still in existence in 1830; the other, situated near the eastern end of the airport runway after it was built, was then demolished for safety reasons. The watermill, at the bottom of Bonne Terre, near Platte Saline, also originated before 1238. It was rebuilt in 1792, and last used about 1920. It is now in ruins.

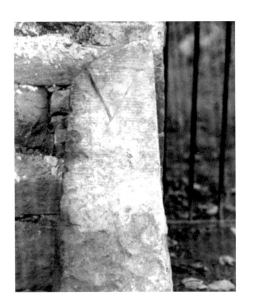
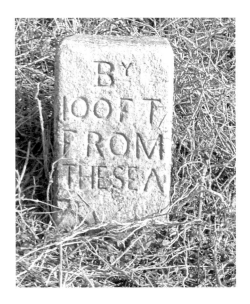

BOUNDARY MARKERS. Above left: to mark the boundary between Franche ('F', free) or Villain ('V', owing service) land. These were erected at or before the Elizabethan land survey in 1572. The 'F' is carved onto the opposite face of this stone. This is possibly the only one still in existence. Above right: when the common lands were divided among the inhabitants in 1830, stones like these were erected to mark the extent of the 100 ft wide strip of land around much of the island above high water mark, reserved by the British Government for their later use, but where the inhabitants were allowed to place their vraic to dry. Below left: an early example of the Alderney Land Commission Boundary Markers, 1950, for plot 16 near Val du Saue. A few of these may be seen. Below right: a much less elegant boundary marker of 1953-5. These are very frequent throughout the island.

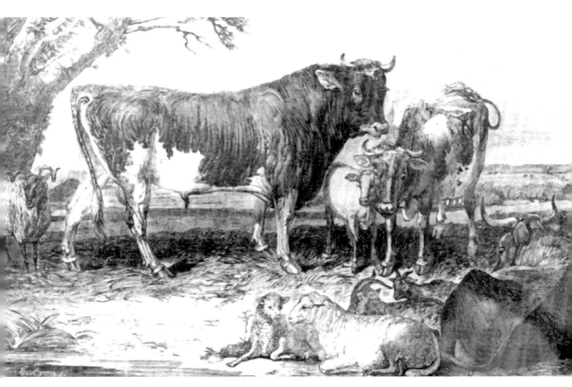

'ALDERNEY CATTLE' from a lithograph, in the Alderney Museum, of the painting by James Ward, of about 1860.

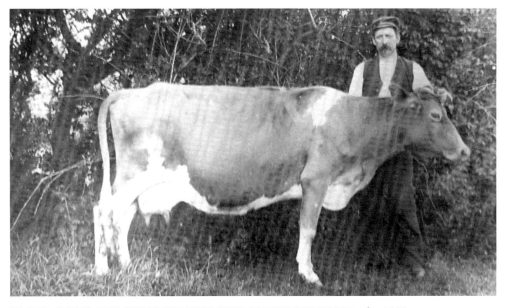

JIMMY CATTS AND HIS PRIZE-WINNING ALDERNEY COW in the 1930s.

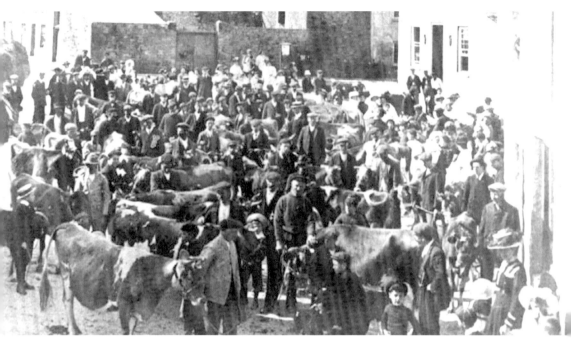

A CATTLE SALE IN MARAIS SQUARE in 1912. Many cattle were exported to America in that year.

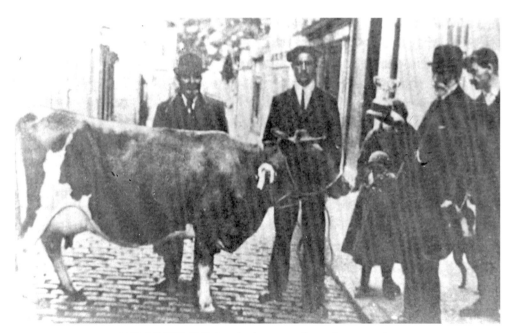

THE WINNER OF THE KING'S CUP for the best cow from the 1913 show, in Victoria Street. The cow's name was Mabel. From left to right: James Audoire, Billy Tuckerman, Mr Sauvary from Guernsey, Ted Audoire.

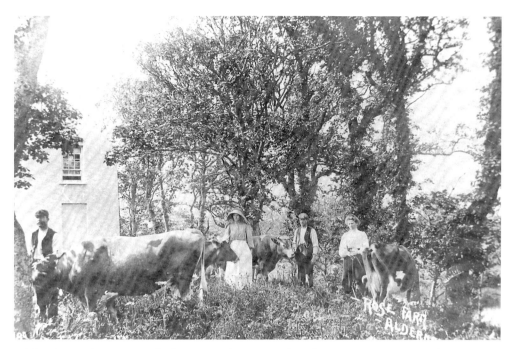

ROSE FARM about 1900. The house now bears a modern date stone '1720'. It was first enclosed as a single-ownership farm about 1820.

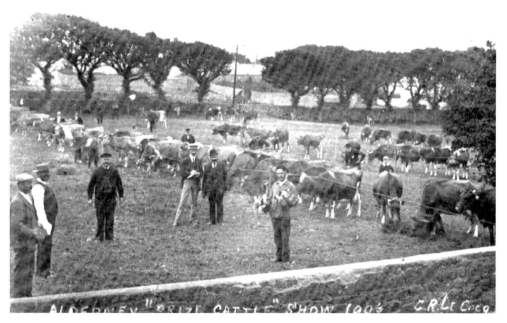

ALDERNEY CATTLE SHOW, 1906, in the Val Field. The roof of the church tower can be seen on the right.

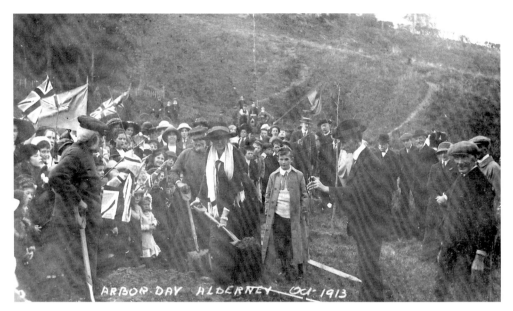

ARBOR DAY, 1913. A tree is being planted by the vicar's wife, Mrs Le Brun, watched by Nick Gaudion.

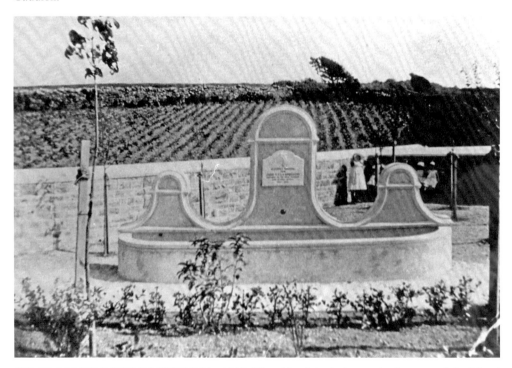

JUDGE BARBENSON'S FOUNTAIN in 1913. The gift of the judge to the farmers of the island about 1902, situated close to the island's principal springs. The entrance to the airport is now alongside it.

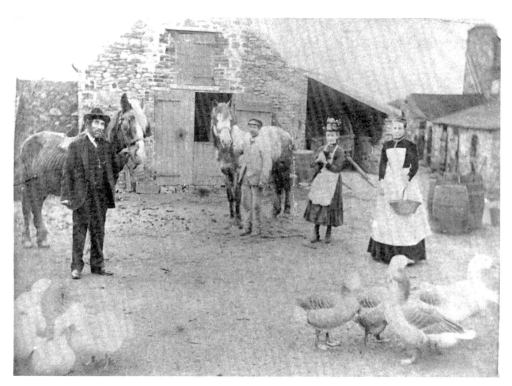

AN ALDERNEY FARMYARD SCENE of the 1890s. Tom Lihou wearing the cap, with his wife Amelia and daughter Elizabeth. Mr Vaugrois of Sark wears the hat.

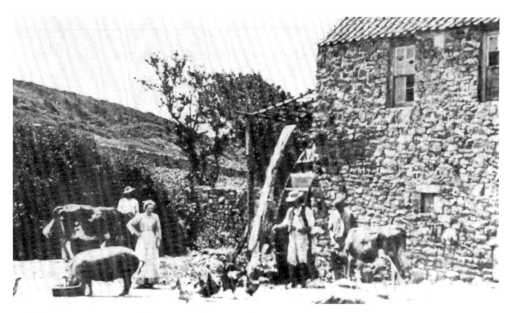

WATERMILL FARM In the 1920s. This is probably the Le Sueur family.

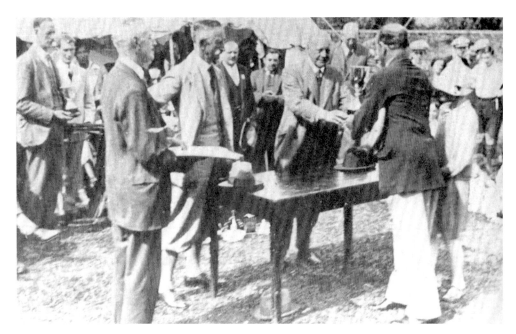

ALDERNEY CATTLE SHOW, 1936.

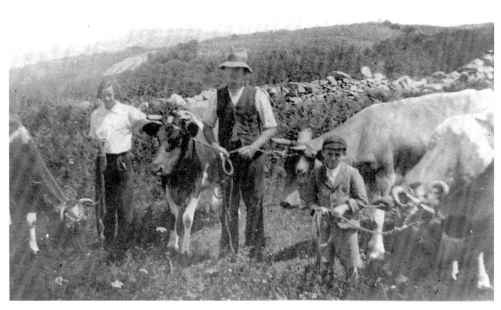

CATTLE BEHIND VAL PLAISANT In 1930. From left to right: Marie Peg (an English visitor), Billie Sebire, Lennie Chivers.

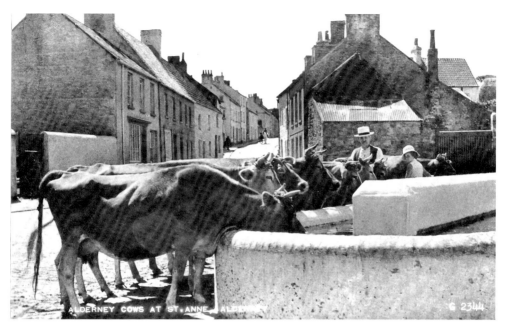

THE CATTLE TROUGH IN MARAIS SQUARE, *c.* 1930. The trough was built about 1885, and for many years after a man was employed to keep it filled and to sweep up the manure from the cobbles.

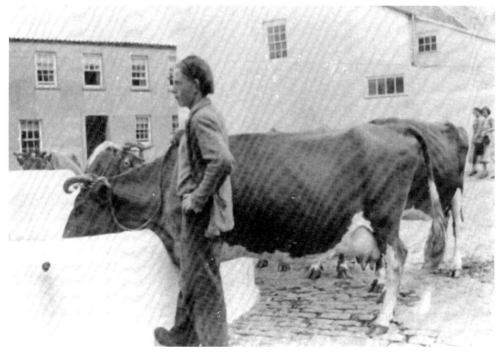

BOY WITH CATTLE IN MARAIS SQUARE IN 1934.

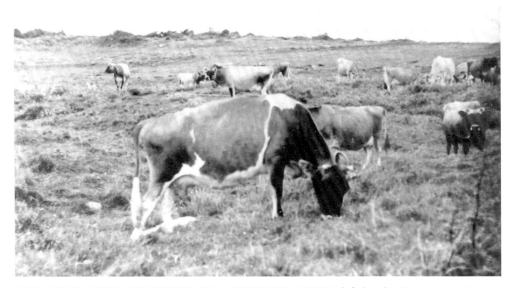

THE MIXED HERD OF JERSEY AND GUERNSEY COWS, left by the Germans on Longis Common in 1946. The Jerseys were soon sent to England as by law, only the very similar Guernsey and Alderney breeds of cattle could be kept on the island.

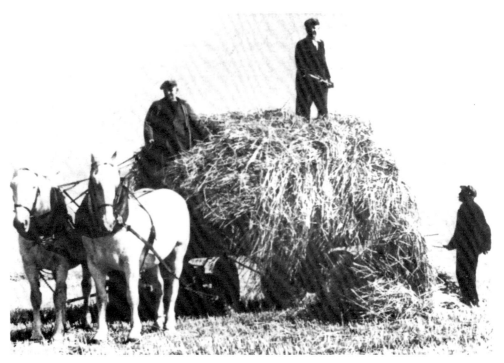

ALDERNEY'S FIRST HARVEST AFTER THE WAR. Making hay in 1946. On the cart Sydney Gaudion, Billy Tuckerman, pitching-up Eddie Burland.

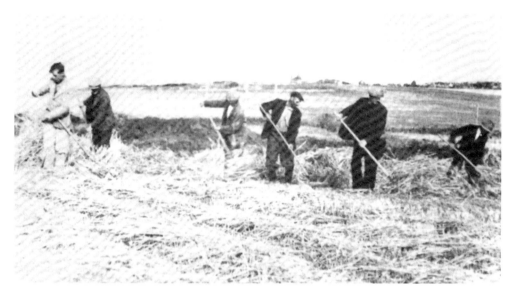

TURNING WET CORN TO DRY for the first post-war harvest on the communal farm, 1946. From left to right: -?-, Tom Burland, -?-, Francis Herivel, -?-, Billy 'Smiler' Mignot.

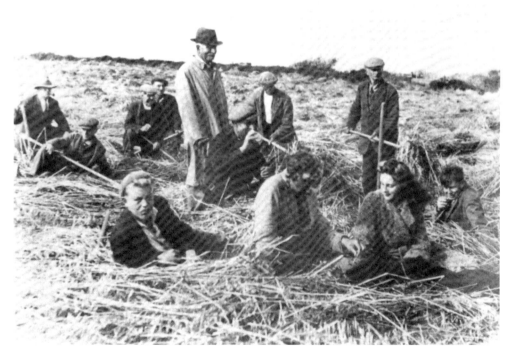

ON THE SAME JOB. From left to right: Billy 'Smiler' Mignot, ? Coysh, ? Carré, the English foreman Mr Passmore, -?-, ? Herivel. Front: Charles 'Barbie' Cosheril, -?-, the ministry lady, rat-catcher, -?-.

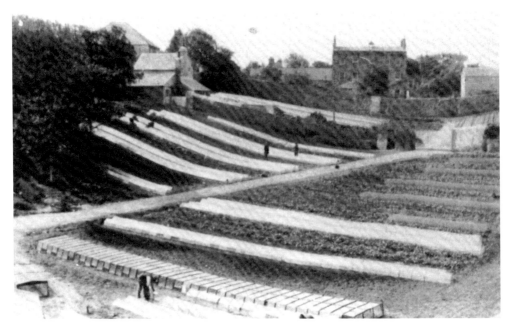

THE VALLEY GARDENS SCHEME. A horticultural venture started by Francis Impey in 1947 to produce salads, vegetables, asparagus, etc., for sale in the island, and for export. The large building at the top is the back of the Island Hall, and this land formed part of the manorial garden in the time of the Le Mesuriers in the eighteenth and nineteenth centuries. Taken about 1950.

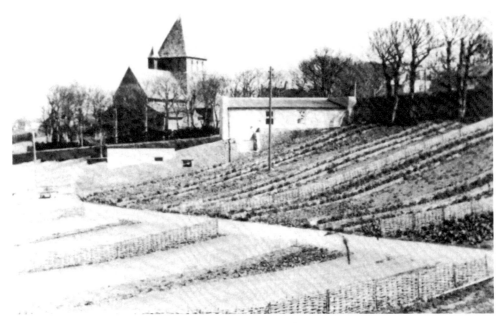

A LATER VIEW OF THE SCHEME from the other end.

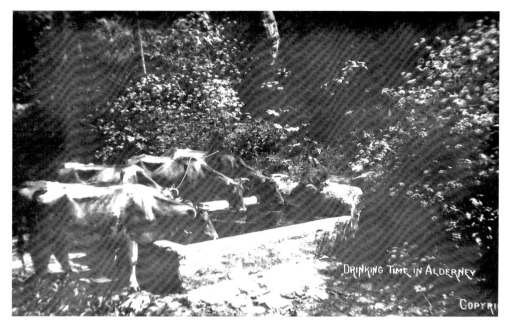

ALDERNEY COWS AT THE TROUGH in Ladysmith. One of Mary Connolly's photographs, from about 1930.

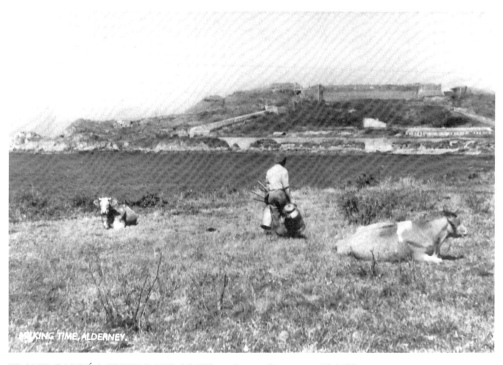

FRANK CARRÉ MILKING HIS COWS on Braye Common, 1946/7.

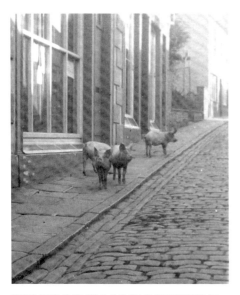

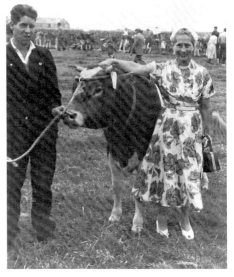

PIGS RUNNING LOOSE IN VICTORIA STREET after the Evacuation in June 1940. This was put out in Guernsey as a postcard shortly afterwards.

SADIE JENNINGS AND NICK CARRÉ, with his father's prize-winning bull at the 1952 Alderney Week Cattle Show.

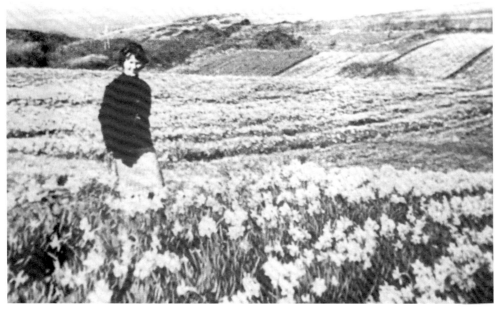

ANOTHER PART OF THE MARKET GARDENS SCHEME about 1952, on the Petite Blaye. Over five million daffodils were sent out in one year, and pickers were flown in from Lincolnshire to help gather the crop.

SECTION SIX

Air, Road and Rail Transport

Alderney was the first of the Channel Islands to have a land-based aerodrome operating regular commercial flights. The first known flight to the island was made when two Avro 504L seaplanes left Southampton on a flight to Jersey, on 5 October 1919. One, piloted by Alan Storey, reached Jersey safely. The other, flown by Pilot Evans, ran into fog and landed on the sea near Alderney. In attempting to enter Braye harbour, it was wrecked on the Breakwater.

On 13 October 1923 a Sea Eagle flying-boat of the British Marine Navigation Company, which had started a service between Guernsey and Southampton a month earlier in company with a similar plane, force-landed near the Casquets on its return flight in heavy seas, Pilot Henri Briard in the second plane landed in Braye harbour and gave the alarm.

The seas were too rough to allow a boat to go out, nevertheless, he took off again, badly damaging the underside of the flying-boat in doing so, but reached St Peter Port safely. The other plane, piloted by Frank Bailey, got out a sea-anchor, but was drifting away from the shelter of the Casquets towards Alderney, firing Verey lights at intervals. In the meantime Trinity House Launch, Lita, *with skipper Nick Allen and pilot Dave Ingrouille, had reached this aircraft. Their dinghy capsized and sank trying to get a tow-line to the plane, but they managed to secure it and towed it to the shelter of Longis Bay. She flew to Guernsey for repairs on 15 October, and was later sunk in St Peter Port harbour on 15 December 1926, after being rammed by a boat.*

A plane from Jersey made the first deliberate landing on the shingle beach at Platte Saline in 1933. It had to be carried up on to the field above the beach by a gang of men from the stone-crusher at the harbour before it could take off again. Services by ordinary planes had already been operating for some time from the beach in St Ouen's Bay in Jersey, and sea-planes landed outside the Breakwater in Alderney and taxied to Braye beach in 1934.

Arrangements were made by Jerseyman Harold Benest to rent fields on the Grande Blaye from the various farmers who owned them, and the construction of the grass aerodrome was officially started on 1 April 1935. It was quickly made ready for use, and the first flight to arrive was a three-engined Windhofer amphibian, coming from Guernsey on 22 May. The first plane from Alderney to Southampton, a De Havilland 84 Dragon, took off on 5 April 1936.

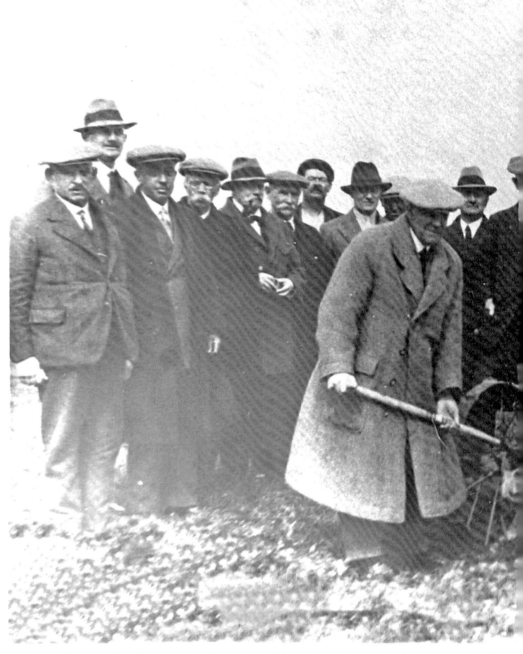

JUDGE R.W. MELLISH OBE turns the first sod on Alderney's aerodrome, 11.15 a.m. on 1 April 1935. From left to right: Jurat D.S. Le Cocq, Capt. F.W. Marriette, W.P. Duplain (Dean of the Douzaine), Charles Batiste (HM Greffier), Lt.-Col. Langlois (HM Receiver), Jurat A.C. Tourgis, Jurat Capt. C.H. Richards, Judge Mellish, Jurat J.J. Audoire, N.W. Gaudion (HM Procureur

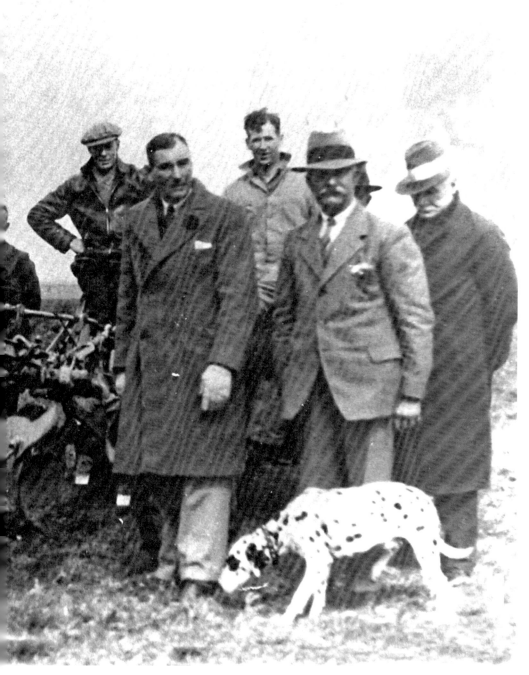

and Lloyd's Agent), W. Simon (cartage contractor), Capt. H.G. Benest (Arpenteur Publique [Public Surveyor] and Jersey Agent for C.I. Airways), Jurat W.H. Mignot, W. Underdown (Prison Governor).

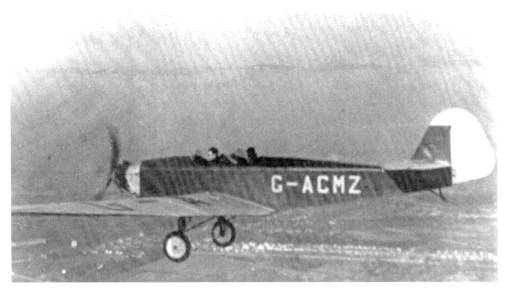

KLEMM MONOPLANE, 1933. A plane of this type was the first to land on Alderney, on Friday 4 August. Piloted by Mr Farquharson, it brought Messrs A. Le Sueur and A.B. Grayson from Jersey. They had to make their way back by sea.

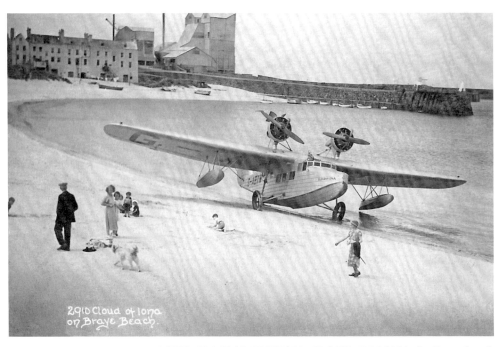

SAUNDERS ROE, FLYING CLOUD CLASS AMPHIBIAN, *CLOUD OF IONA*, On Braye beach in 1935. It and all eleven on board were lost over the Les Minquiers, on an Alderney-Guernsey-Jersey flight on 31 July 1936.

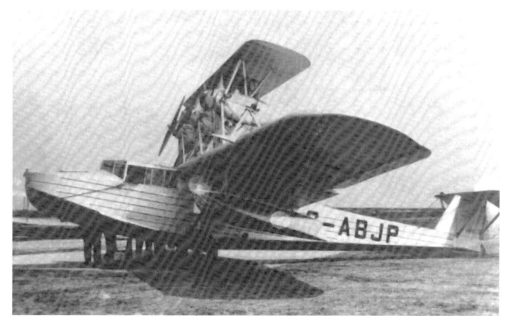

WINDHOFER FLYING BOAT, *Winnie the Pooh*, at Alderney, 22 May 1935. The first plane to land officially at the new airport.

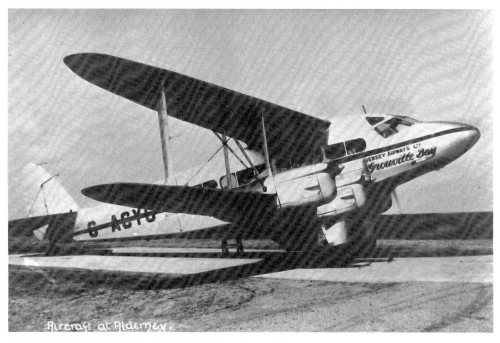

DE HAVILLAND RAPIDE, *GROUVILLE BAY*, at Alderney, 1935.

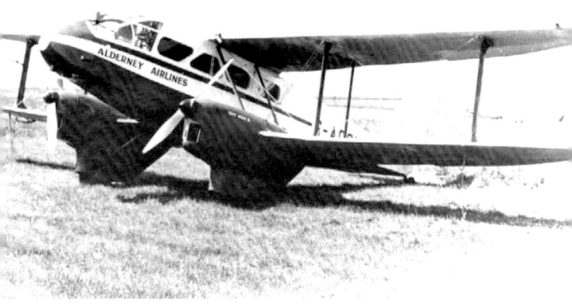

A DH 89 AIRLINER of Alderney Airlines.

THE NEW AIRPORT TERMINAL BUILDING in 1947.

WILMA LE COCQ, Alderney's first airport manager, receiving a telegram about flights, in Victoria Street. September 1936.

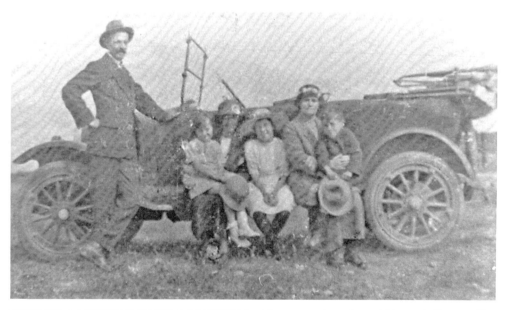

PERHAPS A CHEVROLET OR A MAXWELL, this car may have been Alderney's first car. The Model T Ford of Dr Livesey, brought to the island about 1895, is the other contender for that honour.

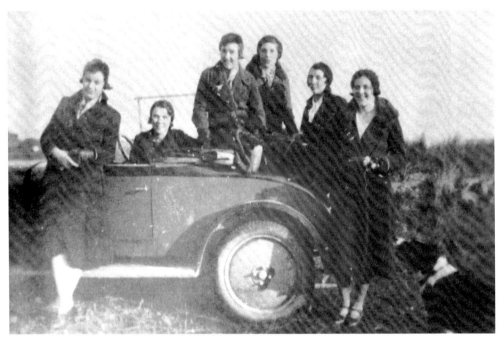

GIRLS WITH A CAR about 1930. From left to right: Cathleen Odoire, Phyllis Brehaut, Queenie Regan, Maggie Shade, Doris Brehaut, -?-.

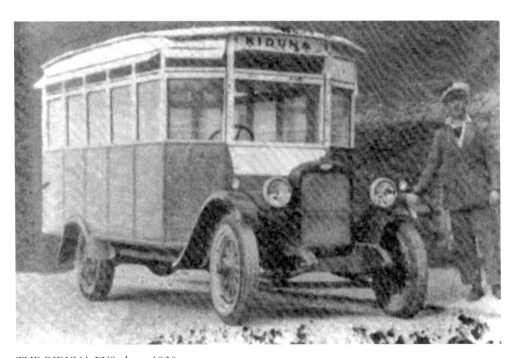

THE RIDUNA BUS about 1930.

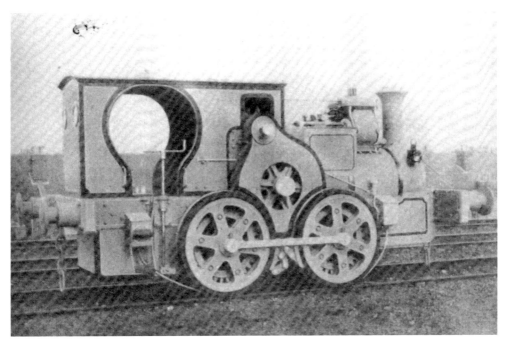

THE ALDERNEY RAILWAY GEARED LOCOMOTIVE *GILLINGHAM* built by Messrs Aveling & Porter of Rochester in 1893.

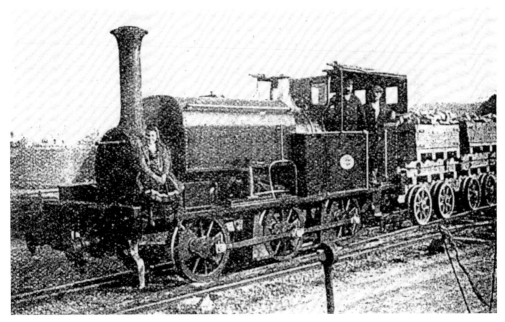

ALDERNEY LOCOMOTIVE NO. 1. A six-coupled saddle-tank locomotive built by Hunslet Engine Co., Leeds in 1880. This picture was taken about 1914.

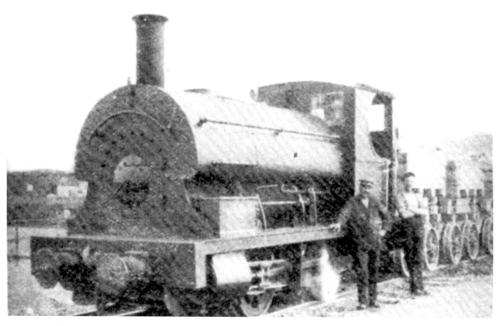

ALDERNEY LOCOMOTIVE NO. 2. An 0-4-0 saddle tank, built by Peckett & Co. of Bristol in 1898, was brought to Alderney in 1904. It ran off the end of the Breakwater with an entire train of stone in a storm in 1911. The men jumped clear and she was salvaged several weeks later and rebuilt. This picture was taken in October 1913.

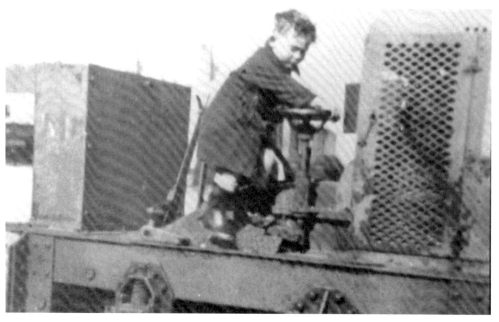

A GERMAN NARROW-GAUGE DIESEL LOCOMOTIVE, used in the quarries during the war. This picture, with young Peter Crump on board, was taken in 1947.

SECTION SEVEN

Coastal Scenes

Alderney's wild and rugged coastline is surrounded by small islets, emergent and tidal rocks, and many reefs. It is the only Channel Island with any sandstone, which covers both the eastern half of the south cliffs, and also forms the offshore reef extending from the Cap de la Hague to the Casquets. Many of the beaches along the southern and western sides of the island are difficult to reach except from the sea.

Burhou, about a mile offshore to the west of Alderney is a wildlife sanctuary, where colonies of puffins, storm petrels, and several species of gull breed. It is closed to visitors during the breeding season, from 15 March to 22 July. The hut may be hired during the open season by application to the Clerk to the States. Visitors must take all their own supplies, including sufficient water for their stay.

THE VIEW FROM THE LOVER'S CHAIR. A sketch by famous Guernsey artist Paul Naftel, about 1880, engraved by S.J. Groves.

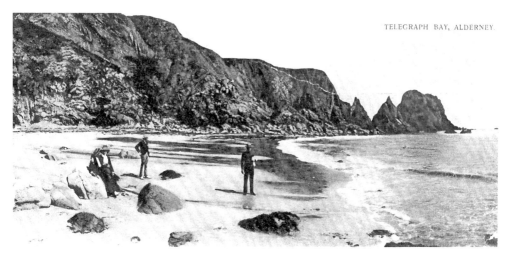

TELEGRAPH BAY, a double width, hand-coloured postcard from about 1900. One of a series of the island by W.R. Gaudion, sold in both monochrome and coloured versions. The telegraph cable, opened in 1868, comes out of the sea from Guernsey by the rocks in the foreground.

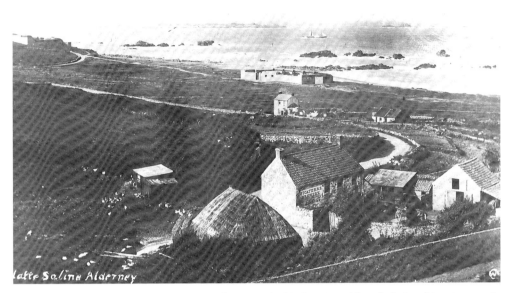

PLATTE SALINE AND THE SWINGE about 1890. SS *Courier* with sails hoisted has just made the passage through the Swinge. The eighteenth-century Platte Saline battery is on the edge of the beach, and the Picaterre Brewery is in the foreground. This is a Westness photograph.

CRABBY BAY about 1905. A photograph by A. Heatley of Guernsey. The railway to Fort Tourgis ran along the track curving round the bay, and the tunnel under it for access to the beach down the vraic road can be seen. The Roman Catholic church and presbytery are at the top of the picture.

PLATTE SALINE On the north coast about 1930. Fort Tourgis dominates the hill, with Platte Saline battery in the centre. The houses on the left were demolished by the Germans to improve their field of fire, and much of the length of the beach from the right to the fort is now occupied by an anti-tank wall. In Victorian times, a narrow-gauge railway from the quarries ran along the line of the footpath from the left, past the seaward side of the battery.

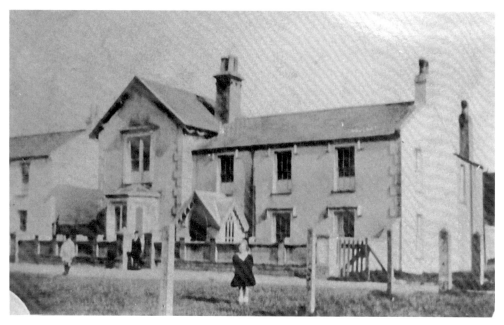

PLATTE SALINE HOUSE in 1924 with the Ainsworth family. From left to right: Peter, Colin, Rose.

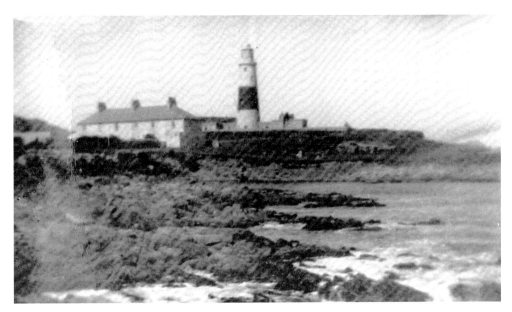

QUESNARD in the 1920s. The houses on the left were built by John Godfray for workers in nearby Mannez Quarry. The buildings in front of the lighthouse are pigsties. The Germans also demolished these houses to give a clear field of fire.

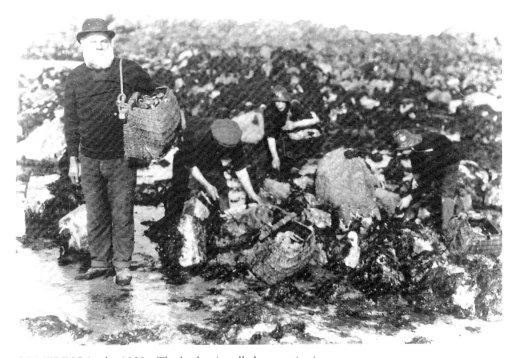

ORMERING in the 1930s. The basket is called a *pannier à cou*.

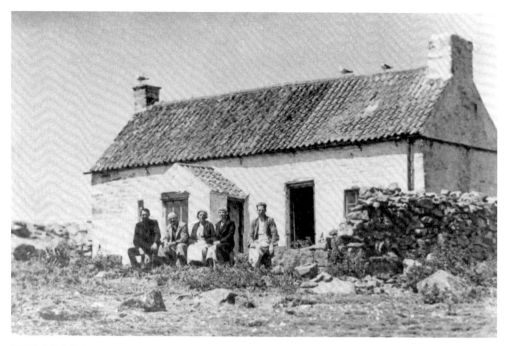

THE COTTAGE ON THE OFFSHORE ISLAND OF BURHOU about 1930.

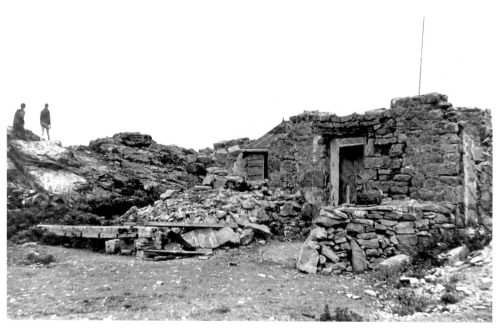

THE COTTAGE ON BURHOU AFTER THE SECOND WORLD WAR. The Germans shelled it for target practice in 1943.

SECTION EIGHT

Lighthouses and Wrecks

Almost three hundred wrecks have been recorded round Alderney's coasts, many of them round the Casquets, at the end of a reef stretching twenty miles from the coast of France, and in the direct shipping route from southern England to Guernsey. A petition was made to the Governor of Alderney in 1709 to have a light erected on them. This was finally brought about in 1724 when three towers, each with a coal fire in an armourer's forge, kept alight by hand bellows, were erected.

This has been modified many times since, and the light changed to a single flashing one in 1877, but the basic structure of the lighthouse complex remains the same. It was electrified in 1952, and at the end of 1990 the lighthouse was made automatic, ending a continuous occupation by keepers, and in earlier days by their families as well, of 266 years.

Alderney (otherwise known as Mannez, or Quesnard) Lighthouse was erected in 1912 after a series of wrecks at almost the same spot directly in front of the lighthouse site. Although sited on land it is classified as a rock station, and now controls both the Casquets, and the Channel Light Vessel.

Some additional wartime wrecks will be found in Section Ten, on the Occupation.

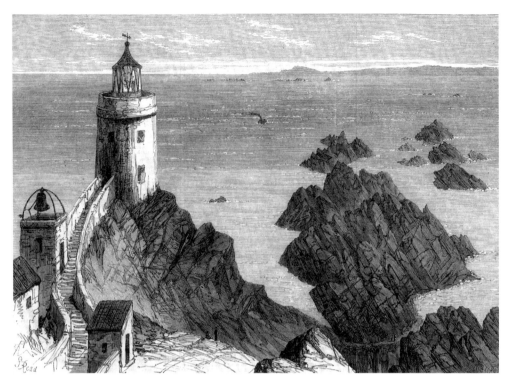

AN UNUSUAL VIEW, by Jackson, published in the *Illustrated London News* in 1868, of Alderney from inside the Casquets Lighthouse. The bell was the fog signal at the time.

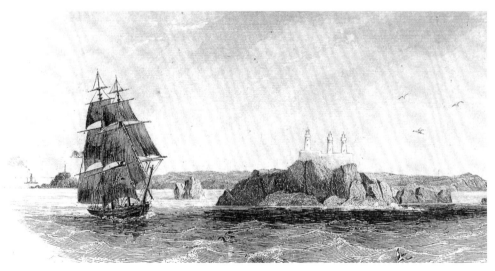

THE CASQUETS AND ALDERNEY. An engraving by Jersey artist P.J. Ouless (1817-85), probably done about 1860. The three towers were of equal height at this period. The signal mast of Mount Touraille shows on the left of the picture.

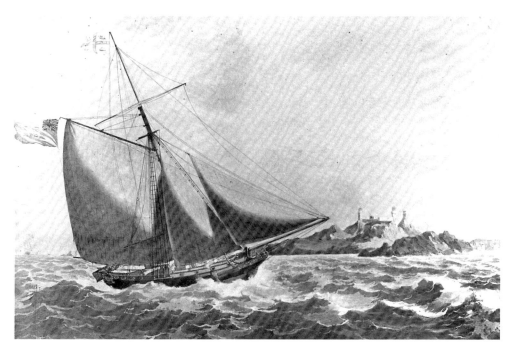

THE TRINITY HOUSE YACHT at the Casquets in around 1800. The original painting by Thomas Whitcomb (1780-1825), from which this postcard was made, hangs at the headquarters of the Trinity House Corporation.

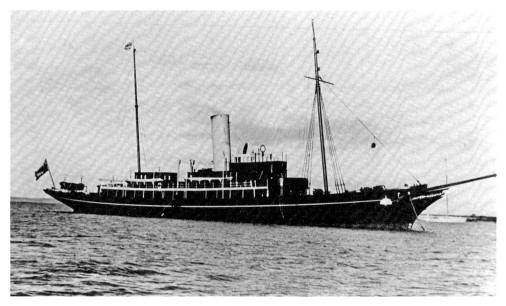

TRINITY HOUSE VESSEL *PATRICIA* in Braye Bay about 1910. She was replaced in 1982 by another vessel of the same name.

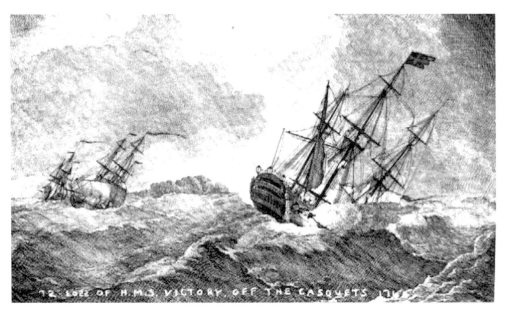

THE WRECK OF HMS VICTORY, lost with all 1,000 on board on 5 October 1744, is recalled in this postcard based on a painting by Peter Monamy. The tragedy occurred some twenty years after the lights were first lit.

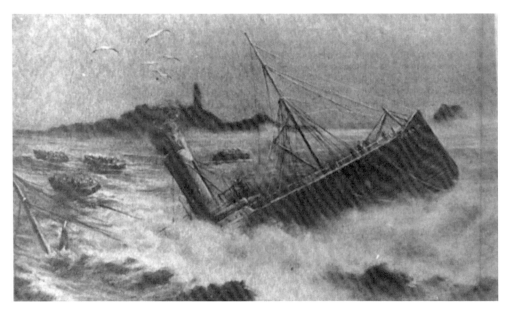

THIS PAINTING BY AN UNKNOWN ARTIST, of the wreck of the L&SWR passenger steamer *Stella* on the Casquets on Good Friday 1899, was published as a postcard in Guernsey soon after the event. One hundred and five persons drowned but one hundred and twenty were saved by a number of other vessels.

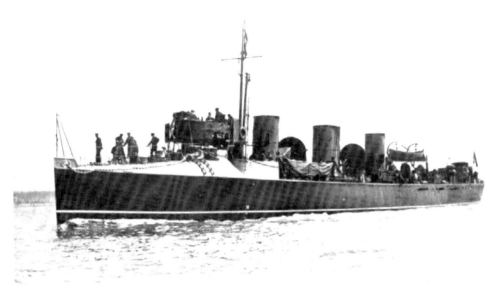

HMS *VIPER*, A TORPEDO BOAT DESTROYER, a new turbine-driven vessel, was the fastest ship in the world, here seen at her sea trials in 1899.

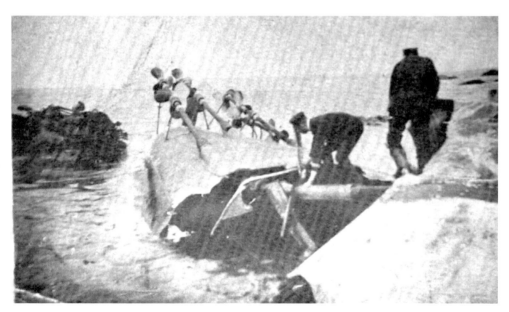

HMS *VIPER*, taking part in the 1901 Channel Fleet manoeuvres round Alderney, ran onto the Renonquet reef just west of Burhou in fog on 3 August. She broke up within two days. Most of her armaments and some torpedos were recovered in the next few weeks. Salvage work in the late 1960s revealed one torpedo tube still loaded, and two others beneath her. The navy blew these up, further damaging the wreck, but a number of bronze items were later recovered.

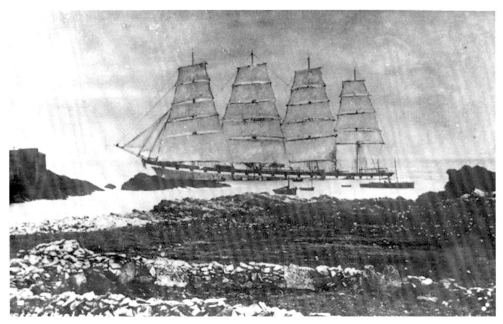

ALDERNEY'S MOST FAMOUS WRECK was probably the 3,400-ton *Liverpool*, the largest sailing ship afloat when she sailed gently into the small island of Les Hommeaux Florains in thick fog, with all sails set, on 25 February 1902. No lives were lost and most of her cargo and gear was salvaged. A series of photographs was taken by Westness as she gradually broke up, and published as postcards.

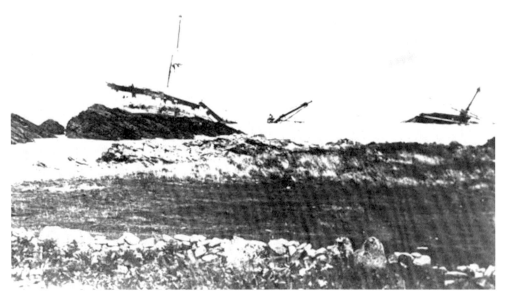

LIVERPOOL HAD ALMOST BROKEN UP when this picture was taken in April 1902.

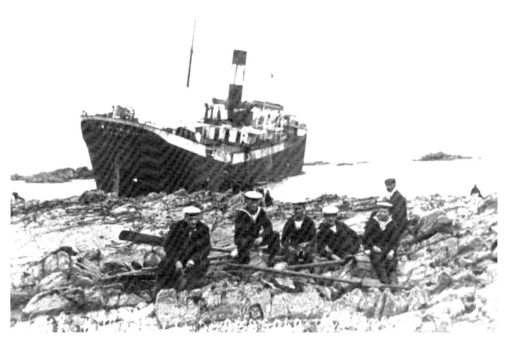

THE FIRST OF FOUR WRECKS in June 1910, the Spanish steamer *Felix de Absasolo* was wrecked on the Bouffresses near Raz Island on the 7th.

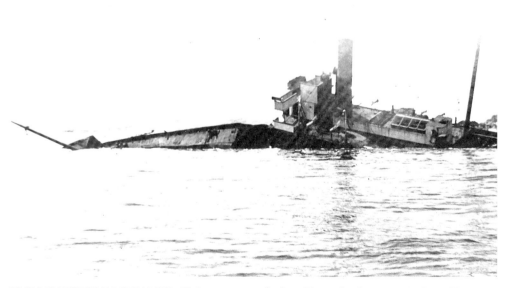

THE NORWEGIAN STEAMER SS *Rap* was wrecked on Pierre des Butes on 11 June. Her crew were towed into Braye in their own lifeboat by the Trinity House tender *Lita*.

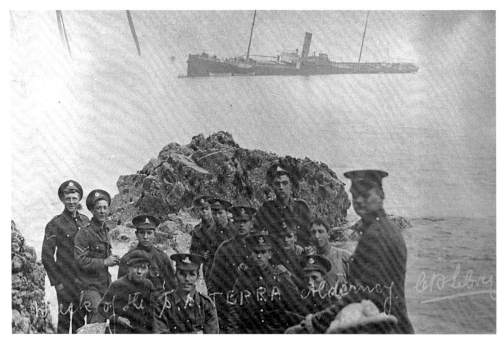

SS *TERRA*, A GLASGOW STEAMER, was wrecked on the Grois Ledge on the same day, 11 June 1910.

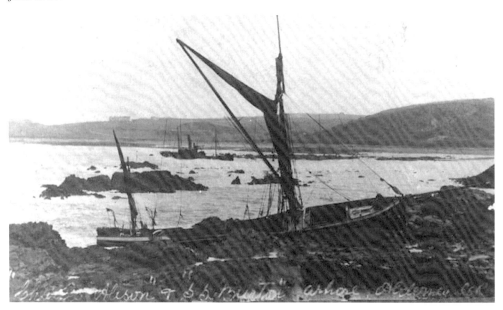

TWO WRECKS OCCURRED IN JANUARY 1911 at almost the same spot. SS *Burton* was wrecked on the Grois reef on the 7th. She was later towed off into the harbour, but broke in two and was a total loss. Her boiler and keel can still be seen at low tide. The sailing barge *Charles Allison* from Rochester, loaded with stone, landed up nearby on the 12th, and was later salvaged.

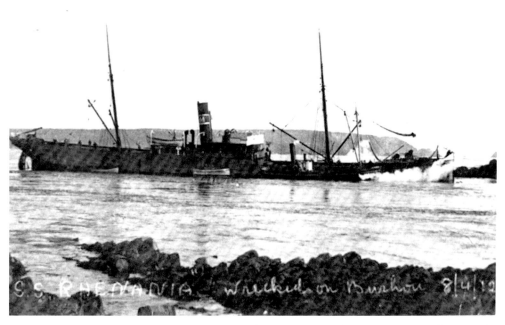

SS *RHENANIA* WAS ALSO WRECKED on Burhou, on 7/8 April 1912. Her crew all got to the island with some of the cattle she was carrying and most of her cargo. She sat there for months and became a tourist attraction, with excursions being run from Guernsey to view the wreck.

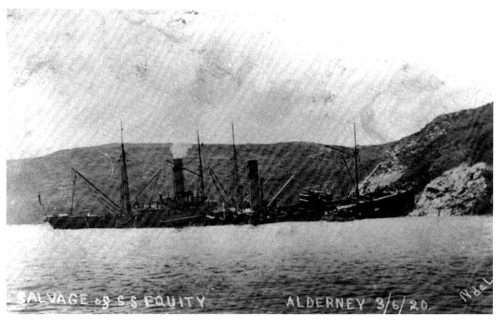

THE SALVAGE OF SS *EQUITY*, by SS *Ranger*. *Equity*, a steamer from Goole, ran onto the rocks below Fort Essex on 26 May 1920. As this picture shows, she was later pulled off and repaired.

THE CONSTRUCTION OF THE ALDERNEY LIGHTHOUSE followed shortly after three wrecks. This picture by C.R. Le Cocq shows the work under way.

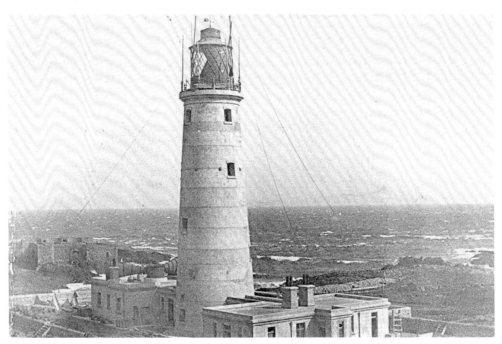

THE NEWLY COMPLETED ALDERNEY LIGHTHOUSE in 1912, before painting with its distinctive white band. This picture is also by C.R. Le Cocq.

The Alderney Militia and the Army

Much of the island's history has been bound up with the need to defend it against possible French attacks. Several took place over the centuries, but the island was only actually occupied for two brief periods – in 1338 and 1558.

The Alderney Militia from earliest times consisted of all the able-bodied men of the island, who had to assemble in times of need, originally at the windmill; but later at the watchtowers. They were often assisted by the women, who kept watch from the various lookout points and beacons, while the men worked in nearby fields.

The militia first became a properly constituted force during the governorships of the Le Mesurier family, and had its first uniforms issued in 1781. From then, compulsory service remained until 1905, when the force was reorganized as a volunteer service. Over a long period from the 1880s, Lionel Langlois, who joined as a junior officer then, but had become its CO and a Lt.-Col. when it was finally disbanded in 1929, chronicled its activities. Some of these photographs are from very faded prints in his scrap-book.

From the sixteenth century various garrisons of English troops were sent to the island to support the militia for short periods, and were withdrawn again when the immediate danger had passed, but from 1782 to 1824 a regular garrison was maintained in Alderney, from units posted to Guernsey or Jersey. From 1824 to '52 there were no regular units in the island apart from a small contingent of the Royal Artillery to help the militia man the guns, but once the Breakwater and forts were under construction, the island was garrisoned continuously until 1929.

THE GORDON HIGHLANDERS and the Alderney Militia assembled on parade on the Butes in 1887, to fire a salute on the Queen's Golden Jubilee.

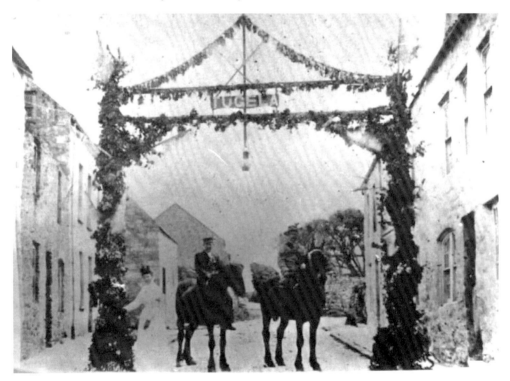

PRETORIA DAY, 6 June 1900. Fifteen triumphal arches and many other gas-illuminated decorations were erected round the town to celebrate the day when Lord Roberts was expected to enter Pretoria (he actually took it on 5 June). The arches each bore the name of a victory in the South African War, or the names of heroes like 'Bobs' and Baden-Powell. This one was at the top of Little Street.

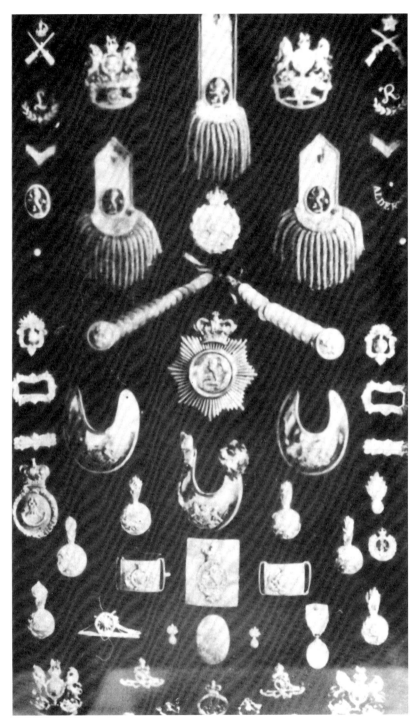

BADGES OF THE ROYAL ALDERNEY MILITIA. A photograph of the display in the States' Building.

133

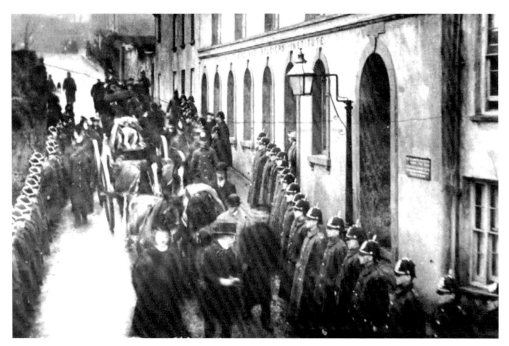

THE FUNERAL OF A CRIMEAN WAR VETERAN. McMurray died in January 1903. His funeral was led by Judge Barbenson and Capt. Serjeanton, with officers of the Leicestershire Regiment, Capt. Arnold and Mr Sinclair of the RGA, Capt. Langlois and Mr Price of the Militia. The RGA were the pall bearers accompanied by the buglers of the Leicesters, and the Rechabite's band. Troops of the Leicesters lined the route.

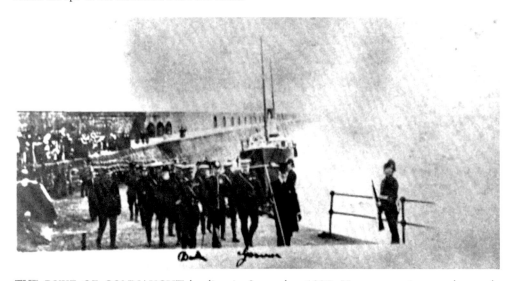

THE DUKE OF CONNAUGHT landing in September 1905. He came to inspect the newly reorganized Alderney Militia, and Royal Square was renamed Royal Connaught Square in his honour.

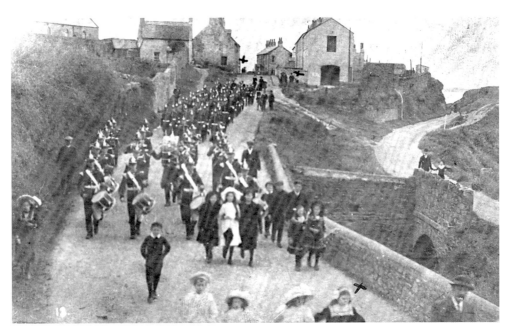

MEN OF THE 2ND BATTALION, ROYAL IRISH REGIMENT, marching round Crabby Bay after a service at the Roman Catholic church, about 1911.

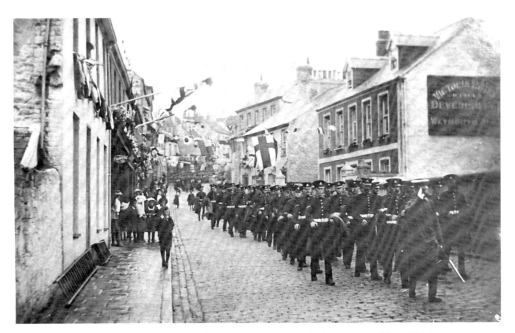

A PARADE IN VICTORIA STREET for the coronation of King George V in 1911.

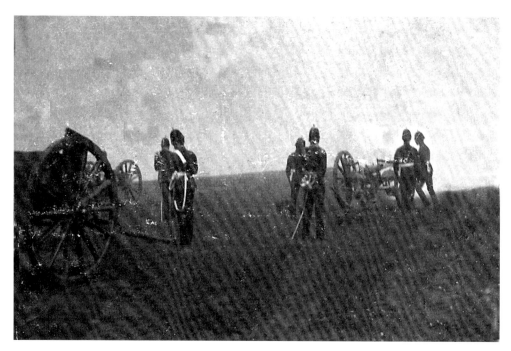

ROYAL ALDERNEY ARTILLERY AND ENGINEER MILITIA firing a sixty-eight-gun salute on the day of the funeral of King Edward VII, 20 May 1910. Capt. Langlois is at the rear of the gun, with Sgt. Maj. Nevitt at the left rear and Capt. Smythe in front of him.

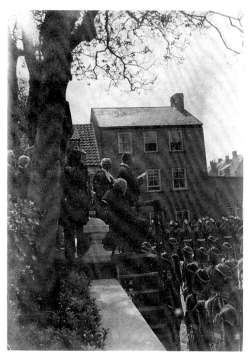

SHERIFF JOHN PEZET reading the proclamation of the accession of King George V in the garden of the rectory on 11 May 1910. Judge Barbenson is on his left, Jurat N. Renier on his right. The 17 Coy. RGA faces the camera, and the band of the Middlesex Regt is in front of the Sheriff.

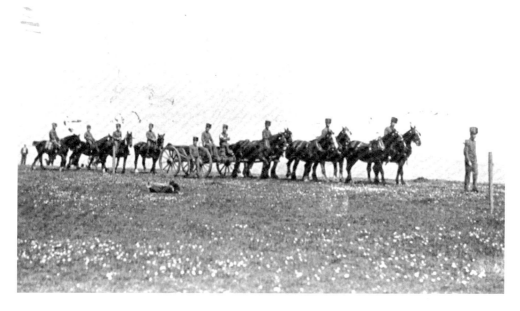

THE ALDERNEY MILITIA ARTILLERY (above) AND INFANTRY (below). These photographs were probably taken in 1935, when the Militia was 're-formed' for a day, with hired uniforms, to celebrate the Silver Jubilee of King George V, and fire a salute. These pictures are undated, but the writing on the back appears to be that of Col. Langlois who is on the left in the infantry photograph. The other is marked, 'I was just ahead of the gun, but the photographer cut me off.'

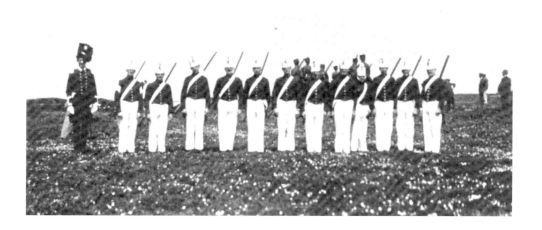

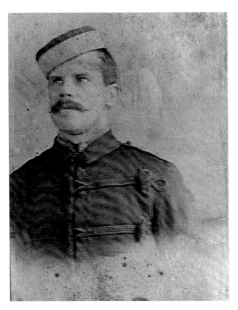

LT. LIONEL J.A. LANGLOIS of the Royal Alderney Militia, 19 July 1900.

BILLY SHADE, about 1950, in the uniform of a trooper of the Alderney Militia of the 1800 period. There were twelve troopers and a sergeant to complement the infantry and artillery, but the unit only lasted a few years.

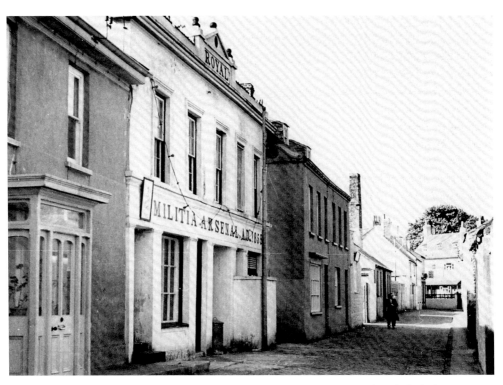

THE MILITIA ARSENAL IN OLLIVIER STREET about 1950. It was demolished about 1970.

SECTION TEN

The German Occupation

The first German forces landed on Alderney on 2 July 1940, about two weeks after the island was evacuated. They found only seven inhabitants left, who had refused to leave their homes and animals. At first the island was lightly occupied by mainly anti-aircraft troops with light anti-aircraft guns, and a civilian administration of the FK515, under Sonderführer Hans Herzog. Camps were soon built to house Organisation Todt workers who would build the defences needed, after Hitler gave orders to turn the Channel Islands into a fortress. At first these were paid volunteers from Europe, but soon included large numbers of slaves of many nationalities, but mainly Russian and Ukrainian. At its peak there were about 5,000 workers, housed in four camps, and 4,000 members of the German armed forces on this tiny island, whose pre-war population was about 1,400.

Many of the slave-workers died here as a result of starvation, overwork, disease or cruelty or were executed. Estimates of numbers vary between the approximately four hundred whose bodies were found after the war in marked graves, and several thousand – the exact figure will never be known.

Several books have been written about this dark period in Alderney's history, with some illustrations. As far as I know, these pictures have not previously been published, except for the two identity card pictures of slave-workers in my own work The Island of Dread in the Channel.

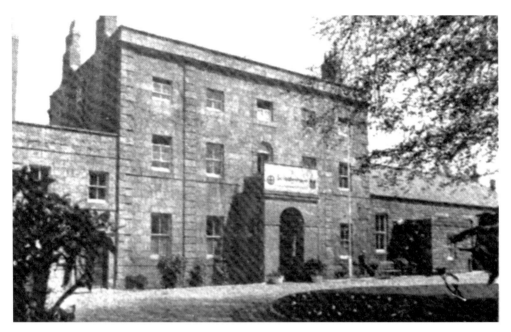

THE CONVENT (now the Island Hall) was turned into a soldiers' home, run by the German Red Cross, while the Rink Cinema, at the junction of High Street and The Val, was turned into a luxury cinema/theatre. These pictures were printed in a German guidebook to Alderney, *Die Inseln Alderney*, published in 1942.

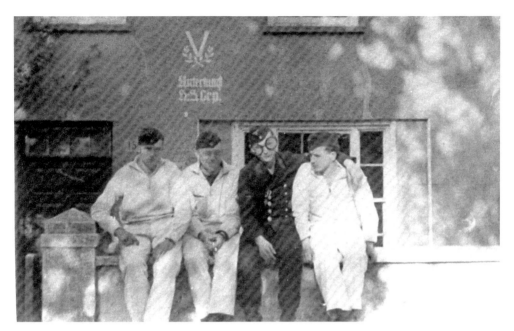

THE HARBOUR GUARD BILLET in Longis Road. The V sign on the wall was originally devised by the Germans to cover over V for Victory signs painted by the local population in occupied areas.

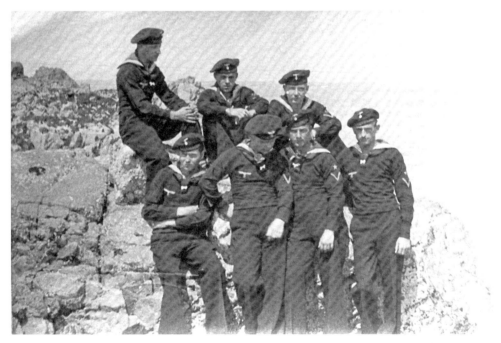

YOUNG SAILORS OF THE HARBOUR GUARD after receiving their proficiency badges at the end of nine months service, August 1942.

GERMAN TROOPS quartered at 45 High Street decorated the ceilings with a number of paintings. This is one that was rescued when the house was being renovated, and is now in the Alderney Museum.

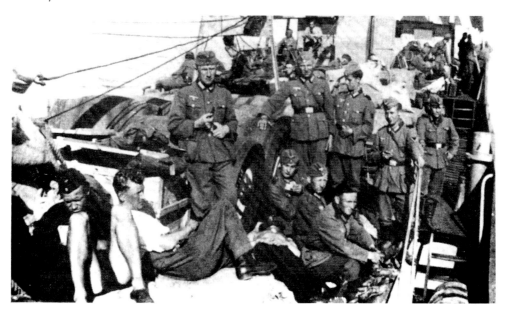

THE FREIGHTER *LENA* at Alderney, July 1941.

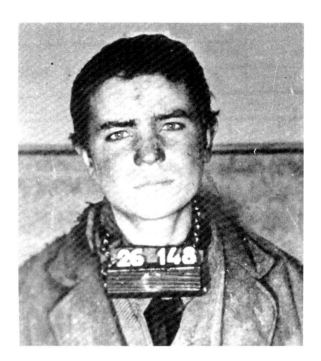

RUSSIAN SLAVE-WORKERS; number 148, Anton Yezhel, and number 206 Alexander Rodine, both aged 16. These are identity card photographs taken at Helgoland Camp, Platte Saline, on 7 August 1942.

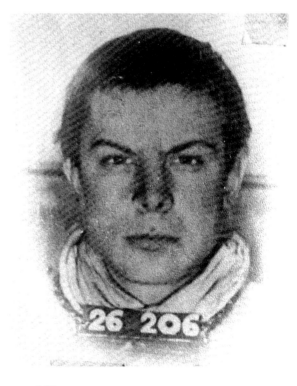

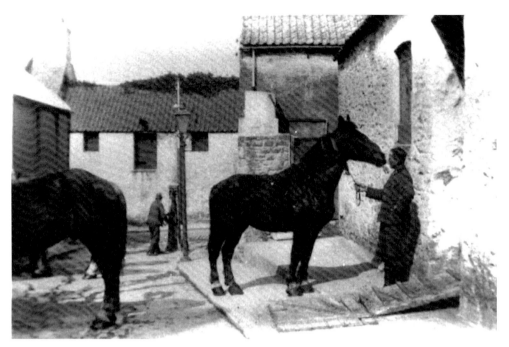

GERMAN HORSES IN SAUCHET LANE in 1942. The old man at the pump is probably the chiropodist, James Alfred Rutter, who lived just around the corner in Victoria Street and who had refused to leave the island when it was evacuated. He was later tried and imprisoned by the German authorities for looting the empty houses before the German forces arrived.

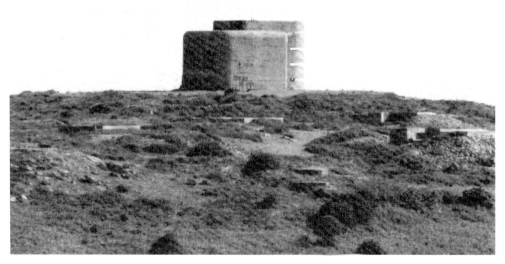

THE 'ODEON', more correctly the *Marinepeilstände*, or Fire Control Tower, at Mannez Quarry. Each of the three floors held the equipment for controlling one of the three main gun batteries. There was a large range-finder on the roof.

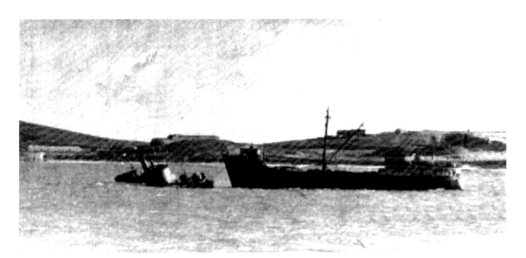

A VIOLENT STORM in January 1943 caused the freighter *Xaver Dorsch*, which was loaded with sick Russian prisoners who were being taken back to France, to break loose from her moorings and drift onto the beach. A number of the prisoners were drowned. Harbour Guard boat *VP 703* attempted to pull her off, and was wrecked on the rocks in the middle of Braye Bay in the attempt. In this photograph, taken by a young sailor of the harbour patrol, she is still attached to the freighter. Her remains are still visible at low tide, together with the remnants of *Henny Fricke*, also wrecked there during the war, and SS *Burton*, wrecked in 1910.

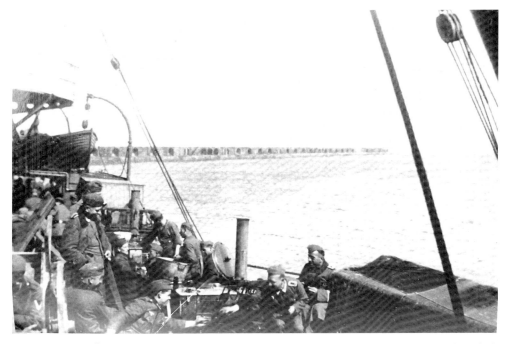

SS *ROBERT MÜLLER 8* AT THE ALDERNEY JETTY, with troops cooking their meal on deck while waiting to go on leave. Easter weekend, April 1942.

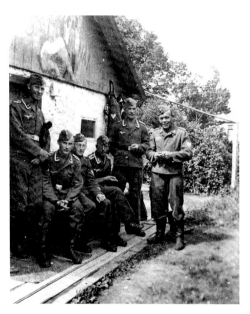

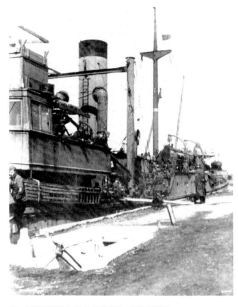

GERMAN TROOPS AT A CANTEEN HUT, probably in the Braye area, in September 1941. Note the mural on the gable.

SS *IRENE* LOADING AT THE ALDERNEY JETTY, Easter 1942.

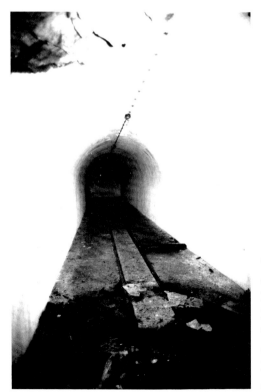

ONE OF THE SIDE TUNNELS from the complex built by the Germans under the Rochers from the south side of the Water Lanes. It is smooth-rendered with cement; was dry and held shelving for storing ammunition, and had a narrow-gauge railway line to move it. This picture was taken by the author in 1990.

The Islanders Return, Alderney 1945–60

The island was freed by British forces on 16 May 1945, almost a week after the other islands were liberated, at which time many of the houses were derelict or totally destroyed. Much rehabilitation work was done by the remaining German POWs and the British Army, before the first islanders were able to return at Christmas 1945. Unlike the other islands, Liberation Day is not celebrated in Alderney, there having been almost no local population to liberate.

Many personal possessions had been looted or moved to different houses, and it was impossible to determine what belonged to whom. At the suggestion of Judge French, all of the furniture remaining in the island when it was freed was placed in store as 'War Booty'. Some was issued to people who claimed items of a certain description, which could be found. The more valuable items of china and silver were sold at auction to those who had already returned. Later, in the summer of 1947, the islanders had to claim what they thought was theirs in a series of races to claim the various items which were laid out on fine days on the Butes. These became known as 'The Battles of the Butes'.

The island was at first run as a communal farm and business, with all males employed at a wage of £3 per week women £2, and juveniles at 1s. per hour. Francis Impey started a market garden scheme in Le Pré de L'Eglise, and later a flower growing scheme was developed on La Petite Blaye, with pickers from Lincolnshire being flown in to help gather the crop. The communal farm was disbanded at the end of 1948, as the farmers wanted to cultivate their own land as they wished, and the market garden folded up in the 1960s owing to difficulty in getting the fresh produce to the English markets.

The Muratti Vase inter-island football competition, the Alderney cattle show and Alderney Week were restarted in 1948; most of the pre-war population had returned by then and new settlers were encouraged. A new Government of Alderney Law came into force on 1 January 1949, Princess Elizabeth and the Duke of Edinburgh paid a visit on 21 June, and Alderney gradually returned to normal.

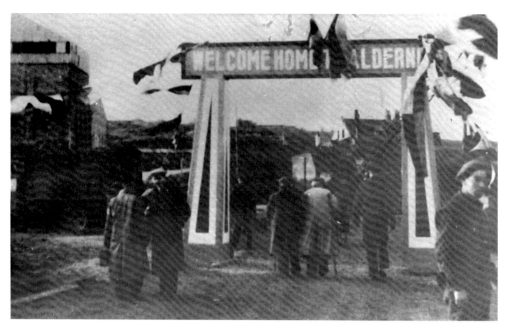

'WELCOME HOME', 1945. The first islanders return. The governor's launch *Guillemot* brought the first party ashore at 10.30 a.m. on Sunday 2 December 1945.

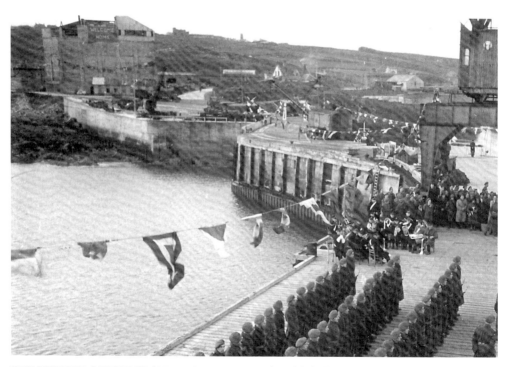

THE RETURN OF THE ISLANDERS. From an article published in *Picture Post*, 12 January 1946.

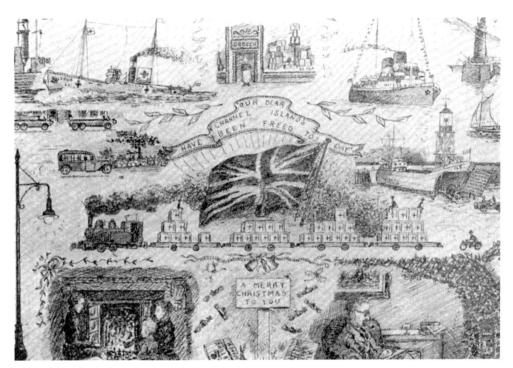

A CHRISTMAS CARD for 1945, drawn by Cyril Ford, to celebrate the end of the war and the return of the people.

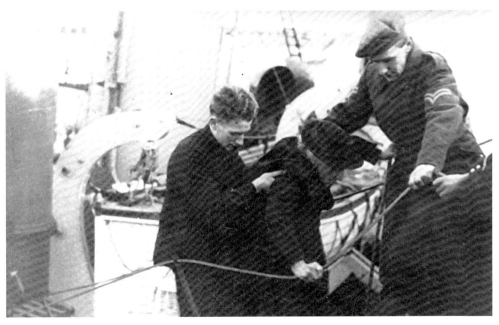

BESSIE DUPLAIN BEING HELPED OFF THE BOAT as she returned to her homeland, later in December 1945.

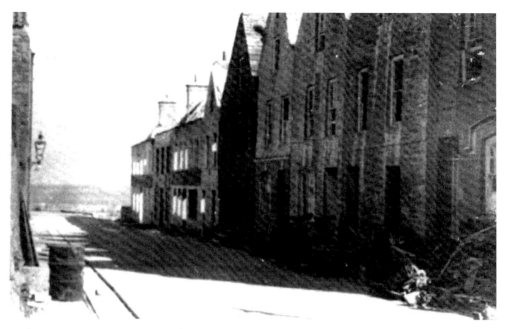

BRAYE STREET in 1946. Most of the houses had their woodwork and roof timbers removed for fuel by the Germans after D-Day, and were uninhabitable when the population began to return. Note the railway lines to the stone-crusher near the quay, on the left.

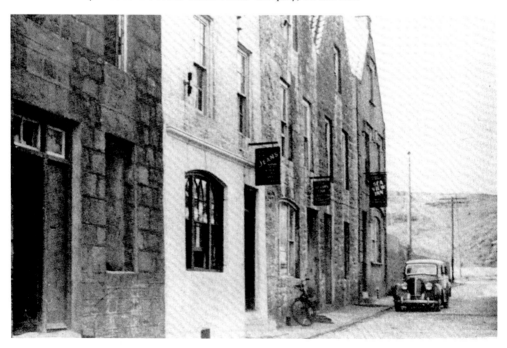

BRAYE STREET in 1947/8. The Sea View, and Diver's Inns were in temporary premises while their original buildings nearer the harbour were repaired.

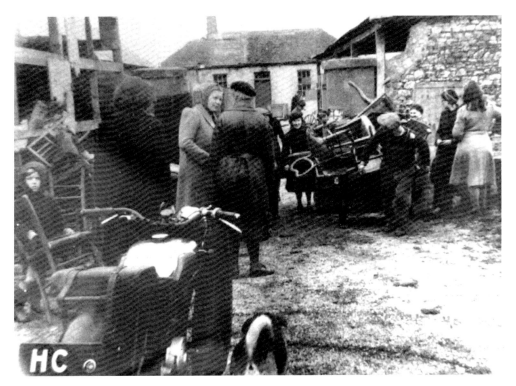

THE BATTLES OF THE BUTES, summer 1947.

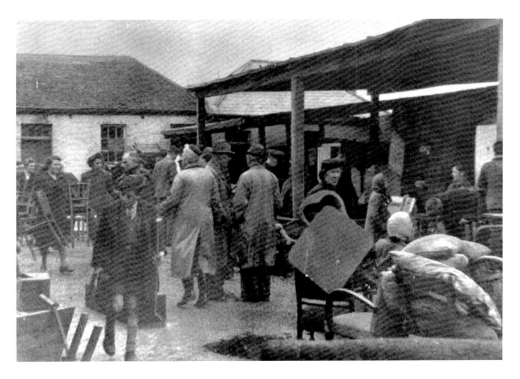

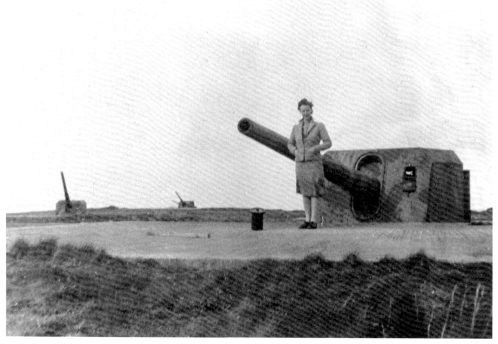

THE FOUR GUNS OF ANNE BATTERY On the Giffoine in 1946. The lady is Jean Mellish, daughter of a former judge of Alderney.

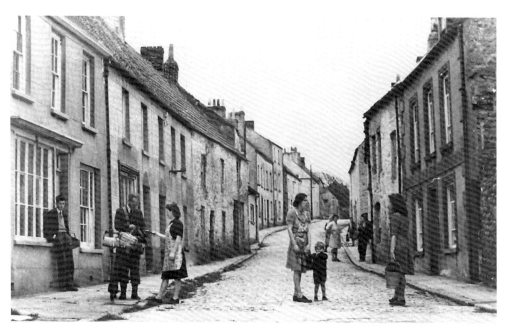

LITTLE STREET in 1946 or 1947. Postman Francis Herivel is delivering mail.

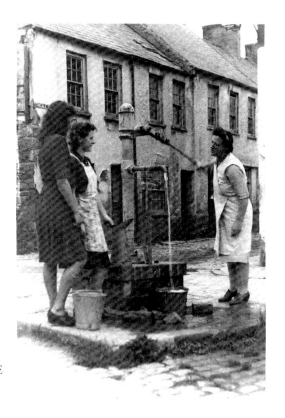

THE PUBLIC PUMP IN MARAIS SQUARE
in 1946. Gwen Sebire is operating the
pump.

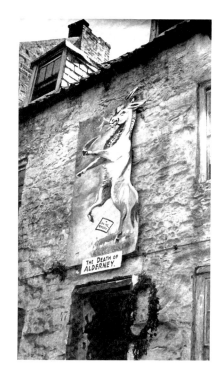

THE DEATH OF ALDERNEY, 1946 or 1947. This
placard was painted and erected outside his house
in High Street, by Ian Glasgow, as a protest against
the proposals for Guernsey to take over Alderney's
administration. The Guernsey folk are traditionally
known as donkeys by the other Channel Islanders.

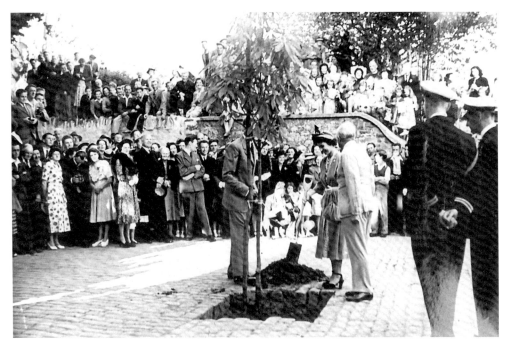

HRH THE PRINCESS ELIZABETH planting an Indian Chestnut tree from the Windsor Park Estate in Royal Connaught Square on 27 June 1949. Francis Impey is on her left.

PRINCESS ELIZABETH addressing the people on Butes, the same day.

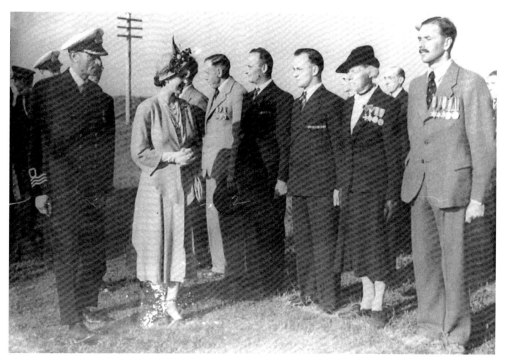

PRINCESS ELIZABETH MEETS SOME OF ALDERNEY'S EX-SERVICEMEN AND WOMEN.
From left to right: Commander Herivel, President of Alderney, the Princess, -?-, Oswald 'Gus'
Riou, Ken Duquemin, Mrs Ramsbottham, ? Dunne. Those behind are unknown.

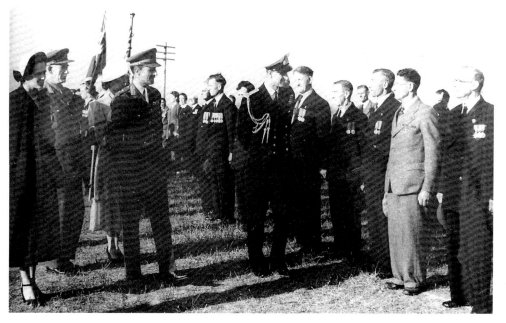

PRINCE PHILIP inspects other members of the group.

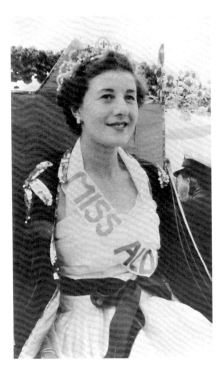

MISS ALDERNEY 1948, Eileen Sykes, for many years now a Member of the States of Alderney, and currently Vice-president of Alderney.

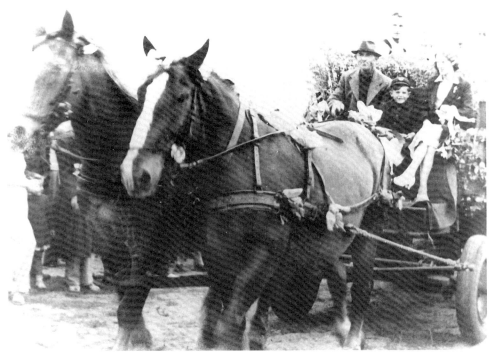

ALDERNEY WEEK CAVALCADE, 1948. Farmer Henry Allen, from Longis Road, is driving the cart, with two of the German horses left on the island.

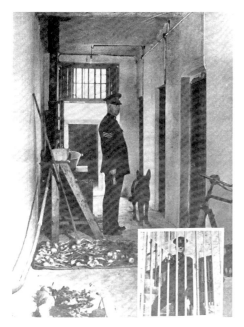

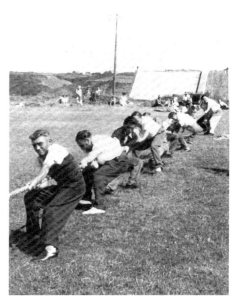

ALDERNEY PRISON on 18 October 1947. Sgt. John Sykes, a retired City of London policeman, became Alderney's 'Law and Order' force.

ALDERNEY WEEK 1952, with the tug-of-war competion. From left to right: Charlie Dupont, Fred Jennings, Joe Critchley, Jon Kay-Mouat.

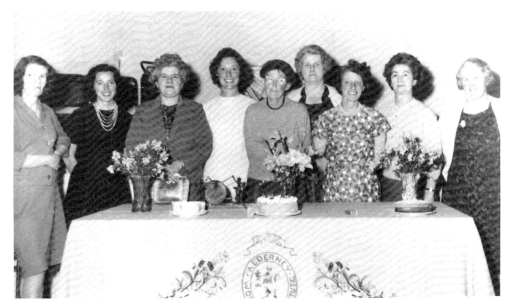

THE ALDERNEY WOMEN'S INSTITUTE in around 1960. From left to right: Anne Allen, Phyllis Welch, -?-, Dot Allen, Queenie Jennings, -?-, -?-, -?-, Mrs F. Dupont.

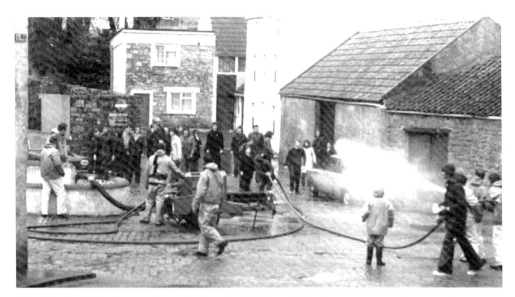

THE TRADITIONAL NEW YEAR'S DAY TESTING OF THE FIRE ENGINE at the Marais Square trough, about 1950. The engine was a 'Godiva' trailer pump, made by Coventry Climax. It is now in the Alderney Museum. This annual ceremony had started in the 1850s, and the object was for the children to avoid getting soaked by the spray. It is thought to have a vague origin in the ceremony of baptism on this day, the seventh day after the birth of Christ.

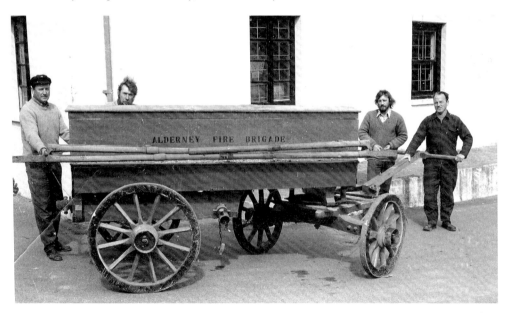

ALDERNEY'S VICTORIAN FIRE ENGINE was built by Shand Mason in 1859, and was last used at the fire at Scott's Hotel in 1924. Found in a shed when the Militia Arsenal was demolished, it was restored in 1975, and is here seen with members of the Volunteer Fire Brigade. From left to right: Albert Rose, Ray Forey, Alan 'Whiffles' Benfield, Ron Rose.

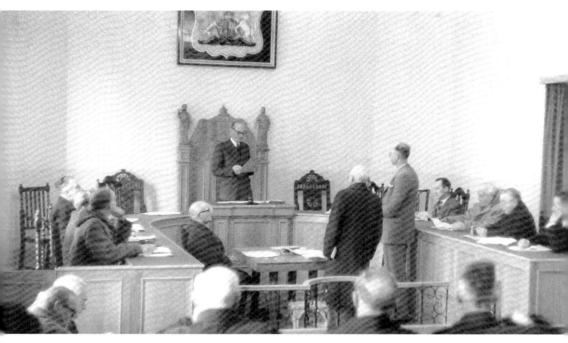

THE ALDERNEY STATES MEETING In January 1955. The President, Cdr S.P. Herivel, swears in Francis Impey in the newly restored States' chamber. Seated in the well of the court, States Treasurer Charles Richards; standing, Peter Radice, Clerk to the States.

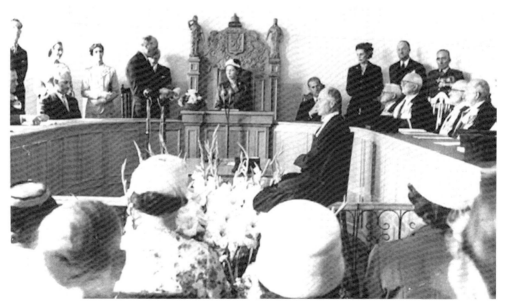

HM THE QUEEN PRESIDES AT A MEETING OF THE STATES OF ALDERNEY on 2 July 1957. President Herivel reads the loyal address.

ACKNOWLEDGEMENTS

Photographs, postcards, paintings and engravings for inclusion in this volume have been graciously loaned by many people and organizations. On a number of occasions the same postcard was offered from several sources and copied. The copy made from the one in the best condition was later selected for use. The owners of each picture will not be identified separately, but thanks for permission to use them, are due to: The States of Alderney; The States of Guernsey; Alderney Breakwater Superintendent, Keith Webster; The Alderney Society; The Priaulx Library; The Alderney Library; The Alderney Journal; the Channel Island Occupation Society.

Individual photographs or pictures have been loaned by the following, many of whom have died in the last eighteen years, listed in alphabetical order:
Elizabeth Beresford • Charles Brown • Victor Coysh • David Duplain • Andrew Eggleston
John Elsbury • John Everett • the late A.H. Ewen • Roger Finch • Dan Godfray
Helen Gough (neé Odoire) • 'Buster' Hammond • Maisie Herivel
Richard Heaume • Fred Jennings • Alan Johns • Richard Lamerton • Graham Lawson
Helmut Lucke • the late Alasdair Alpin Mcgregor • Jean Mellish
Group Captain E.F. Odoire • Peter Radice • Bill Rowe • Dick Le Sueur
Jack Quinain • Roger Warren.